Recto / Verso :

Art Publishing

in Practice,

New York

Hauser & Wirth Publishers

Foreword

Michaela Unterdörfer,
Director of Publications, **Hauser & Wirth Publishers**

Approaching the book as a valuable site of idea exchange has been fundamental to Hauser & Wirth Publishers' program since its founding in 1992. In our work with artists, scholars, and designers, we aim to construct publications that make accessible the various discourses of contemporary art through an aesthetically-thoughtful object.

As art publishers, considering how best to achieve this forms the basis of our daily work. In August 2018 we partnered with Artbook @ MoMA PS1 Bookstore for *Recto / Verso: Art Publishing in Practice*, a series of panels and workshops in which we invited a variety of other individuals and organizations who define art publishing at large to publicly discuss their methods and positions in their cultural ecosystems.

What works? How does it work? What does not, and what are the circumstances that make that the case? Constant critical interrogation of this practice, from its basis to its limits, is necessary to be able to engage with the public and the art publishing community in real, concrete ways—to accomplish the task we have set for ourselves.

Following this methodology to its logical conclusion, the information generated during *Recto / Verso* has been compiled into this volume as both a record and an invitation to continue these conversations. Each chapter corresponds to a week of *Recto / Verso* programming, including excerpts from the panels and workshop outlines, as well as contributions from series participants and information about their respective practices and organizations.

Given New York's storied past and dynamic present as an important center of art publishing—from punk zines downtown to museum monographs uptown—the series and publication take the city as a case study, while also acknowledging that these systems of course exist in similar forms elsewhere, and these topics—aesthetics, politics, public discourse—are of universal concern.

We are truly excited to have been a part of these conversations and are thrilled to offer this publication as a platform for the ideas discussed here to be taken up, taken apart, and taken further.

Preface

Paige Landesberg, Bookshop Manager, **Hauser & Wirth Publishers** and
Kristen Mueller, Buyer & Manager, **Artbook @ MoMA PS1 Magazine Store**,
Recto / Verso series co-curators

Recto / Verso set out to provide the public with an opportunity to engage with the field of art publishing through both a reflective and generative approach. The series gave publishers, artists, and scholars an opportunity to meditate on where art publishing is today, where it has been, and where it is going. Equally important, it strove to create a platform for resource-sharing, education, and engagement in the field for those who are new to art publishing or hoping to experiment.

Art book fairs have contributed greatly to the rise in popularity of the medium, in part because of the accessibility they offer to those involved in the publishing process. Art publishers represent their own work at these fairs, as distinct from the model of traditional art fairs, where galleries typically act as liaisons between artists and the public. This refreshingly authentic face-to-face interaction with makers is a rare experience in the contemporary globalized art world that we now live in.

Recto / Verso sought to foster that same level of transparency while pushing the boundaries of typical art book fair conversation, creating discourse around contemporary art publishing through a dialogical structure. Positioning publishers in conversation with one another and the public opened up conversations about the relevance of this creative field and how to remain engaged and innovative.

Throughout the history of the practice, various groups—from grassroots political organizations to voices in historically marginalized communities—have deployed art publishing as a means to widely distribute their ideas. *Recto / Verso* was an instance of institutional forces at Artbook @ MoMA PS1 Bookstore and Hauser & Wirth Publishers coming together to champion the work of independent publishers, big and small. The series gave shape to the work of individual practices that together form a nuanced picture of how art publishing is intertwined with contemporary culture at large.

VERSO

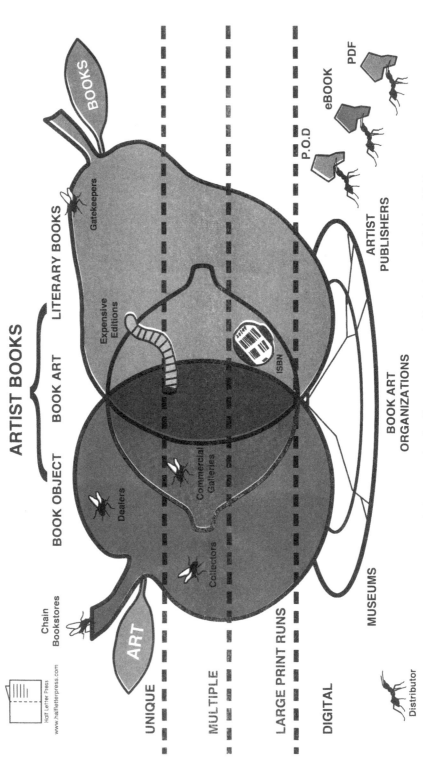

Figure 1: Clive Phillpot's diagram updated to illustrate new complexities in the age of digital publishing

The Life

Art books offer a method of curating ideas into a totally ubiquitous structure; the public's familiarity with the form of the book as an object is one of the medium's great strengths. These publications play a crucial role in the contemporary art ecosystem in that they make it possible for the public to learn about and take home the same critical ideas that are presented in art spaces throughout history.

In our increasingly global web-based culture, brick-and-mortar spaces like bookshops, libraries, and art book fairs have become sites of resistance in their championing of live interactions between people and objects over efficiency. Public programming has become a popular approach to foster community and discourse around art publishing within these spaces. That said, our inevitable dependence on the digital world invites art publishers and readers to find creative online alternatives that contradict the notion of the Internet as an inherently passive and over-saturated space by providing tools and platforms for engagement.

This chapter excerpts a panel discussion between **Emmy Catedral**, **Sharon Helgason Gallagher**, **Nicole Kaack**, and **Lisa Pearson**, moderated by **Megan N. Liberty**, which focused on the circulation of art books. Exploring the medium's unique ability to move between and function in various spaces—from exhibitions to commercial spaces, the digital world to library archives—as well as the opportunities this fluidity creates for artists and publishers, the threads of their conversation are further taken up in additional written contributions by each of the panelists.

of Art

Also featured here is documentation of a web-to-print workshop, led by artist and publisher **Paul Soulellis**, in which participants collaborated on a publication that combined digital and analog media. 📚

Books

The Life of Art Books:

Emmy Catedral
 Coordinator of Fairs and Editions
 at Printed Matter
Sharon Helgason Gallagher
 President and Publisher of
 ARTBOOK | D.A.P.
Nicole Kaack
 Dedalus Fellow in The Museum of
 Modern Art Archives
Lisa Pearson
 Publisher at Siglio Press

Megan N. Liberty *moderator*
 Art Books Editor, *Brooklyn Rail*

Megan: I thought we'd move through the different types of spaces that books move through and talk about what works well in those spaces, some of the challenges of those spaces, and some of their opportunities. We're in a bookstore, so let's start by thinking about the bookstore space. All of you work with books in various ways, but you know that they live at least one life on the shelf or on a table in a bookstore. So what happens when books are in the bookstore? Sharon, I thought we might start with you.

Sharon: Well, the first thing is that this assumption is wrong. *[Laughter]* The book isn't necessarily going to make it into a bookstore.

Megan: How do they enter the bookstore space?

Sharon: I think that a lot of people coming to this talk are interested in artists' book making. So why does a bookseller want to carry your book? He or she may personally like it, but at the end of the day, he or she has to pay rent, has to pay utilities, has to pay for their staff—and the way that you're supposedly going to do that is by selling books, right? And not relying on what, increasingly at the BookExpo and trade convention, are called sidelines, or cafés. If you can't run your bookstore just making money on the books, you're not going to last very long. No matter how many cafés and massage chairs and other things you add in. *[Laughter]*

So go into a bookstore and think, why did the bookseller buy those books and put them there? What am I not seeing? What am I seeing next to it? If I were coming in with my book, where on the shelf would I want it to be? How would it look relative to them? How is its price point relative to them? Does it fit on the shelf?

You see the shelves in this store were specially designed by Skúta Helgason to carry art books, so they have flexible shelving height. The Walker Art Center has fixed height shelving and they're quite large, but *not always large enough*. People often get the question, especially about a large photo book, "Sorry, can you give me the dimensions again? Damn. No, I can't shelve it. Let's move on to the next title." That was the end of that book in the physical bookstore space.

So I basically am asking stores to take some books off their shelves to put ideally more books in the future up on those shelves. So go into a store with

TOOK PLACE AT ARTBOOK @ MoMA PS1 BOOKSTORE, LONG ISLAND CITY, NEW YORK, ON SUNDAY, AUGUST 5, 2018.

Circulation,

different eyes. That's my best recommendation for a potential publisher.

Nicole: How does that function in relation to having an ongoing relationship with a publisher? For example, with Lisa?

Sharon: We have two paths of entry to our distribution program. One is working with publishers like Lisa, like the Museum of Modern Art, where we know that we are willing to take them on. We've looked at the books. We've vetted them. We've sussed them out. *[Laughter]* We're willing to work with them long term and will take on whatever they publish. We don't sign a lot of new publishers like that, however, because it's really a long-term commitment to whatever you're going to do. But in order to keep ourselves young and fresh, we also work with small publishers buying on an exclusive wholesale basis.

Lisa: As an independent publisher, before I was with D.A.P., I dealt directly with bookstores. And each bookstore, especially in the age of Amazon, those stores have had to reinvent themselves as highly curated spaces. As places where communities can gather or where there are events, just like we're doing now. And the book buyers, the people who run those bookstores, have a vision for their store, and they know their communities, and they know who their readers are. Ultimately all of this is about getting these books into the hands of a reader who will engage that book, and love it, and have a relationship with it.

Emmy: A lovely thing about Printed Matter is that it also is a capsule of history, the history of artists' books. Visiting it is visiting an archive. There are shelves upstairs that tell you the history of artists' books.

Megan: Another physical space in which we encounter books is the exhibition space, where there's usually a physical barrier between us and the books, which prevents us from having a tactile experience of books. But it presents other opportunities that artists can play off of. Nicole, you've worked a lot on book exhibitions at MoMA and your independent curatorial projects. Would you like to start us off with your thoughts about the exhibition space?

Nicole: It's always a sacrifice of the tactile. In the MoMA archives, it often ends up becoming a book mounted on plexi and you're just exhibiting a front of the thing, exhibiting the design of it, but always sacrificing the real intent of its creation. There's also the iPad version, which can be even worse. *[Laughter]*

Megan: It allows for people to sequence through, though, which is nice.

Nicole: Yes, exactly. One part of my research interest is Seth Siegelaub and his *January Show*. In 1969 he did a show between January 5 and 31 where he created two rooms. In one room there were thirty-two conceptual art pieces—or the traces of thirty-two conceptual art pieces. In the other room he had just the catalog. And the idea that the book

Distribution,

object realizes the exhibition better than the exhibition does itself is definitely related to this idea of the book being that immediate place of experience.

Megan: The library is another space I wanted to get to. Nicole, you see the way people interact with materials in the archive space, as well as working with artists who use the archive as their material.

Nicole: There has been some beautiful scholarship lately on the tactility of archives. As an archivist/librarian I can transition between that space of reverence but also be in the stacks where there are beautiful objects that reveal themselves to you slowly. One example being *A Juniper Tree* by David Horvitz. It's this beautiful case, produced by Small Editions, and inside is a bottle of gin and a glass, and it's for the lonely librarian to encounter. You know, sneaking a glass of gin in the middle of the day. Thinking about how that book lives its life in a different way than papers, for example.

Sharon: Does someone refill the gin?

Nicole: We actually just refilled it. *[Laughter]*

Emmy: I'm also the cofounder of the Pilipinx American Library, a mobile non-circulating library that works with other small groups, like Wendy's Subway, to share the Pilipinx experience in various printed matter. And Wendy's Subway has been a wonderful capsule of all of these various artist-run libraries. For example at BAM [Brooklyn Academy of Music], inviting artist-run libraries to make ten-title selections for their Reading Room.

Or there's the wonderful platform that is Montez Radio, which is for librarians and people with various book practices to come and speak about their projects through pirate radio. So that's kind of a library project that's unbound.

Lisa: I think one of the things that is tragic for libraries now is that their space is being taken away by institutions. There was recently a big kerfuffle about the Fine Arts Library at the University of Texas at Austin. I think there was also a huge thing about what they're going to take out of the stacks here at the New York Public Library. So now libraries are moving away from physical books in some way. And the books I do, librarians have a really hard time with, because they don't have dust jackets and they do sometimes have little bells and whistles that can be taken out and away by patrons. So because of a funding crisis, they're having to rethink the way they manage information that inhabits both books and digital platforms. And in the advocacy mode, support your local library, for that reason.

Megan: The last type of space, which I see as a nexus for all of these, is the art book fair. It allows for the exchange aspect of the way books circulate. Our ability as an exhibitor to share space with other people, to exchange materials, to exchange ideas. It's a way for books to circulate more freely than in these other spaces and it's performative. There is also the romantic ethos of it: the artists' book as shared community object that is passed around. Many of

and

you were at Press Play, Pioneer Works' book and music fair, yesterday. Lisa, you talked about where your table is placed, in terms of how people enter the fair and the other tables around you.

Lisa: Well, heat and air conditioning has a lot to do with it. *[Laughter]* Where you are in the fair, where people can stand to linger a while, is very important. You know, doing what I do, I am alone. All day, every day, in my barn upstate. And at the fairs, it feels like I am fused with the energy of all these other people who are also sort of alone in their barn. You get a real shot in the arm and it's from your fellow publishers. It's from the people who come up and stand at my table and really look at a book and spend time with it. And then I can have a conversation with them about it. It's so moving and gives me so much energy to go back to my desk and say, "Okay, wait. You are not insane. Other people are responding to this."

It's also great to see because everybody doing independent publishing, when you're this small, is really making it up as they go along. Everybody does it very idiosyncratically, according to the way they have thought through and figured out the challenges, many of which Sharon talked about earlier. So you see everybody's struggles and the ways in which they have thrived, and that is so heartening. You learn something from it too. I learn a lot from my fellow publishers and I learn a lot from the people who come to my table, also in the way that they respond to things. So it's the best situation, at least for a small

publisher like me, to be at the fairs. Your contact is direct and immediate.

Emmy: I was there yesterday, and it was a really lovely feeling of observing exchanges happening. There's something about the book fair where it really allows you to be aware of each other. Of what we're all doing and what projects we have done since the previous year. I've been an exhibitor and part of that also is the programming. Not just tabling, but having the conversations. Press Play was unique in that it was one big open space. You saw the stage and the conversation happening while you were also walking around and talking to each other. We're talking about these physical spaces and that's where you can have the exchange. It's not just the book but also the larger idea of exchange. ♦

Exchange

The Hybrid

In 1980 artist and publisher Ulises Carrión famously wrote in his manifesto "The New Art of Making Books," "A book is a sequence of spaces."[1] Books open up to us; both physically and metaphorically they create a space that we as readers enter. But they also occupy space—on bookshelves and in museums; in private libraries and public stacks. Within this, the art book is unique in its ability to circulate through a diverse range of spaces, functioning differently in each.

Consider the phrase, "the sociability of books," which suggests a mobility that draws people together: the ability of books to both be and create shared spaces, to speak to each other and to readers. In his preface for *Artists' Books: A Critical Anthology and Sourcebook*, Dick Higgins offers up a definition of the artist book, "It *is* a work. Its design and format reflect its content—they intermerge, interpenetrate. [. . .] The experience of reading it, viewing it, framing it—that is what the artist stresses in making it."[2] In the same anthology, Lucy Lippard similarly defines these objects as a "lively hybrid of exhibition, narrative, and object—cinematic potential co-existing with double-spread stasis."[3] This multidimensional nature is discussed at length by artists' book scholars like Johanna Drucker, who writes in *The Century of Artists' Books,* "artist's books are almost always self-conscious about the structure and meaning of the book as a form."[4]

The structure and meaning of the book as a form enables the circulation of art books and their ability to move between various spaces: exhibition, commercial, and research. An art book often exists in several of these spaces at a time: in a museum or gallery space it is an untouchable art object; in the bookstore it's a tactile possession, an object to be sold and bought; and in a library or archive it's a container for knowledge, an object for use. This multiplicity of functions offers nearly endless possibilities for artists and publishers who take advantage of this hybrid aspect of the art book.

As part of a series of posters that addresses self-publishing, Kione Kochi updated librarian and scholar Clive Phillpot's iconic 1982 *Artists Books Fruit Diagram* to reflect the new complexities in the age of digital publishing (see p. 8).[5] Phillpot's original illustrated the overlap between unique and multiple book objects, as well as the intersection of art and books in the form of book art, book objects, and literary books. But Kochi adds aspects of contemporary circulation to this, such as print-on-demand, ebook, and PDF publishing, as well as other more traditional lines of distribution like dealers, collectors, and commercial galleries, each of which bring books into the different types of spaces I've outlined.

Space

I'd like to extend this examination of circulation to the art book, rather than just the artists' book. An artists' book is, as I've suggested, something scholars and artists are eager to define. Part of this means restricting the material that belongs under this label, as Phillpot does in his extensive writing on artists' books: "the definition of artists' books given above also excludes the handmade book as craft object, the limited edition or unique—and often expensive—*livre d'artiste*, indeed most of the area previously denoted by 'the art of the book.'"[6] It's this other material that I'd like to include, with art book as a larger umbrella that encompasses artists' books, as well as collections of artists writings, photo books, and other forms of published art material.

The real question of these materials, as Lisa Pearson writes in "On the Small & the Contrary," reprinted in this volume (see pp. 16–17), is, "How does one possibly get books like these into the world? We collaborate with artists and writers to realize their vision on the field of the page, in the space of the book." Once created, how do these objects enter these spaces and reach our hands and eyes? How do these spaces activate the book? Are the spaces barriers or facilitators in the art book's function? The previous dialogue covers each of these spaces, but it also demonstrates the unique challenge in pinning the book down. Books call out to us to be read, and in the case of art books, they demand a certain level of activation that includes deep reading as well as looking.

[1] Ulises Carrión, "The New Art of Making Books," in *Artists' Books: A Critical Anthology and Sourcebook*, ed. Joan Lyons, (New York: Visual Studies Workshop Press, 1985), 31.
[2] Dick Higgins, A Preface, in *Artists' Books: A Critical Anthology and Sourcebook*, ed. Joan Lyons (New York: Visual Studies Workshop Press, 1985), 11.
[3] Lucy Lippard, "Conspicuous Consumption: New Artists' Books," in *Artists' Books: A Critical Anthology and Sourcebook*, ed. Joan Lyons (New York: Visual Studies Workshop Press, 1985), 49.
[4] Johanna Drucker, *The Century of Artists' Books*, (Granary Press, 1995), 4.
[5] Clive Phillpot, "Books, Bookworks, Book Objects, Artists' Books," *Artforum* 20, no. 9, May 1982, 77.
[6] Clive Phillpot, "Artists' Books and Book Art," in *Booktrek* (JP Ringer, 2013), 48.

On The Small

While I was in Prague, before the Velvet Revolution, I read one of the samizdat copies of Milan Kundera's *The Unbearable Lightness of Being*. It was an unbound, mimeographed typewritten manuscript, no different in its physical form than a thick stack of Communist-era restaurant menus listing the various permutations of pork, beef, and *knedliky*. With nothing to signal that it was a published, much less revered work of literature, Kundera's book existed in the most utilitarian and urgent of forms. Someone had taken great risks to retype the entire work—not from the Czech original but from a smuggled English translation.

So, here was a book that did not look like a book and furthermore was cloaked in a foreign language. Its status was not a book to be placed as a treasured object on the bookshelf; rather, it was a collection of pages, printed in soft, purple type, meant to be read, to be truly consumed and devoured, and then to be given away. While this particular work of beauty and nuance by an exiled writer was far more subversive than any blatantly political tract, the physical form of the book, the fact of its translation, and the necessity of its dissemination also profoundly affected both the act of reading and one's role as reader: Kundera's words challenged a whole gamut of accepted truths. Holding on to it was not only a dangerous act—a punishable offense if you were caught by the authorities—but also a selfish one. By passing it on, you shared the risk as well as gave a gift: each reader became a publisher, albeit very much through the looking glass.

Siglio is not a political publishing house, but it is committed to various kinds of subversions. This samizdat copy of *The Unbearable Lightness of Being* serves as something of a totem for Siglio: as an act of resistance to the literal, the authoritarian, and the facile, as the result of undeterred ambition to share a work of art that might otherwise remain unseen and unread, and as a testament to the "book" as refuge, dissent, beacon, *and* nexus. The subversion—in the works Siglio publishes and in the ways it publishes them—begins by looking askew at the accepted paradigms, locating their absurdities and constraints, and then imagining other possibilities. Thus, the invisible is rendered visible, unexpected connections are revealed, categories dissolved, and a space is opened for contradiction, heterodoxy, ambiguity, as well as—and most importantly—for play and wonder.

Siglio publishes uncommon books that live at the intersection of art and literature. These are hybrid, interdisciplinary works that are often unwieldy, expansive, uncategorizable, and inimitable. In them, the relationship between word and image neither illustrates nor explains, thus they challenge the reader to engage in multiple, diverse, and perhaps unfamiliar modes of reading in which the act of looking is inextricably intertwined. They are not necessarily the books that larger publishing houses have rejected; rather, they are the books those publishing houses may never

ORIGINALLY PUBLISHED AS SIGLIO PRESS, (AMERICAN BOOK REVIEW 31, NO. 4, 2010): 10–11.

imagine. Together, they are (and will be) a rigorously eclectic and dynamic constellation of works that—rather than stake out a specific territorial subject or aesthetic stance, rather than serve an argument or fit a particular trim size—are connected by their way of seeing the world through the looking glass.

How does one possibly get books like these into the world? We collaborate with artists and writers to realize their vision on the field of the page, in the space of the book—the site of primary experience—rather than designing a book to simply document the work. Therefore, we eschew the book as a transparent delivery device and embrace it as a very particular physical object that embodies the work and thus shapes the reader's direct engagement with it. We cultivate and locate audiences for each book rather than selecting and tailoring a book for an intended demographic. That means we trust the immense appeal of a beautiful and unusual book and never underestimate the curiosity, intelligence, and daring of the reading public—or the knowledge and passion of booksellers and reviewers. And we take nothing for granted: every stage of the process—from editorial to production, marketing to distribution—is highly individualized because every book deserves its own particular path into the world, into the hands of readers. Perhaps we can only do this because Siglio is so small, or perhaps Siglio is so small because this is how we publish books.

and

Small press and independent publishing is crucial in a pluralistic, democratic society—it is a stalwart against the expanding homogeneity of the marketplace and the hegemony of the most dominant voices. There is a long history of contrarian and visionary publishing that, given human nature and a means of dissemination, virtually no circumstance will abate. So it's not a question of whether such publishing endeavors inflect the culture at-large: yes, of course, they do, and yes, of course, they don't. We do not have power to wield; rather our influence percolates unpredictably here and there, and thus is neither easily measured nor controlled. Perhaps the question is an existential one: how do we see the world differently through the lens of our engagement with it—through the books we publish and by extension through the artists and writers whose works we champion, and the conversations and relationships those books generate? ◈

The Contrary

"The whole thing is a game, one which, with the help of this kind of information, counts on casting the anchor of a vehicle somewhere close by, so that people can later think back on it. It's a sort of prop for the memory, yes, a sort of prop in case something different happens in the future... I'm interested in the distribution of physical vehicles in the form of editions because I'm interested in spreading ideas."

"Questions to Joseph Beuys," in Jörg Schellmann, ed., *Joseph Beuys: Multiples* (Munich and New York: Edition Schellmann, 1997).

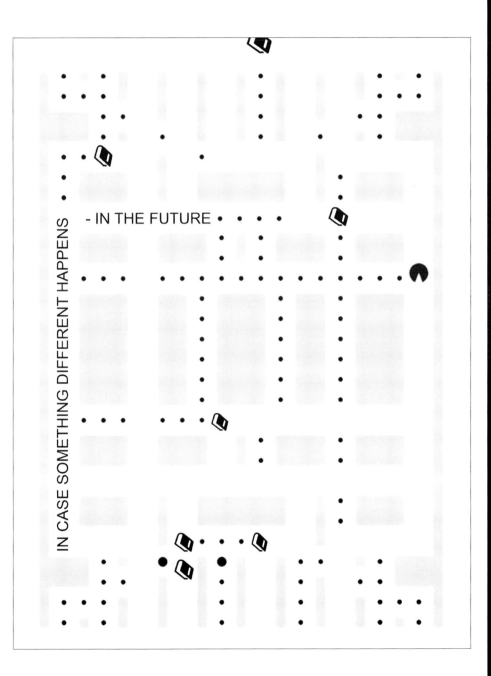

IN CASE SOMETHING DIFFERENT HAPPENS - IN THE FUTURE

Towards a

Seth Siegelaub's exhibition *January 5–31, 1969* spanned two rooms on the third floor of 44 East 52nd Street—a front office containing desk and catalog, and a second room containing the material evidence of conceptual projects by Robert Barry, Douglas Huebler, Joseph Kosuth, and Lawrence Weiner. In the floor plan for the show, Siegelaub drew an architectural comparison between catalog and gallery space, allotting rooms of equal size to both the book and to the "'physically' exhibited" works.[1] However, it is precisely this physicality that is called into question by the two rooms, and by the premise of a show with "32 Works" but "0 Objects."[2] Rather than implying equivalence, the direct contrast between the spaces of gallery and catalog demonstrated the primacy of these conceptual projects as possibilities more appropriately communicated through language and documentation than through the residues of physical enactment.[3] As Lawrence Weiner wrote in his statement for the catalog, to fabricate the work *or not* were alternate possibilities "each. . . equal and consistent with the intent of the artist."[4] Gathering concepts without over-determining their format, the catalog could become a context for art while preserving the either-or of words as potential energy or idea.

Siegelaub is remembered foremost for his role as publisher and organizer of New York conceptual art, pioneering the format of catalog as exhibition. However, by 1971, Siegelaub would depart from the art community to follow politi-

cal interests to Europe, finally settling in Bagnolet, a commune on the outskirts of Paris. It is here that he established the International Mass Media Research Center (IMMCR), a library and study center that aimed to compile resources on leftist discourse and the politics of information dissemination. Between 1972 and 1980, the IMMRC released a series of bibliographies titled *Marxism and the Mass Media*, publishing as a subsidiary branch of Siegelaub's imprint, International General. The seven bibliographic installments cataloged texts and reference books that Siegelaub gathered from a broad network of political activists and members of the press.

Basic

The bibliographies structure themselves as layered binaries that formally mirror the ambiguous materiality of *January* and other catalog exhibitions. On this dual identity, Siegelaub elaborates, "the bibliography is a reflection of two distinct and interlaced phenomena: the concrete reality of the development, practice and struggle in the area of communication; and the analyses arising from, and in relation to, this reality."[5] However, further the relationship of Marxist writings to the movements themselves, the bibliography offers further material indexicality. In 2013 Siegelaub said of a later textile bibliography, "the intention is clearly to produce the universal library of books, or universal bibliography."[6] In a logic that follows that of his previous catalog exhibitions, Siegelaub refers to "bibliography" and "library" almost interchange-

ably, suggesting that books of text are ultimately reducible to their contents and, as such, the ideal space of encounter for disparate units of information.

If Siegelaub's bibliography compiles a list of equal but discrete parts, so too does the *January* show, the announcement for which denotes "1" beside the names of each of the four artists. In spite of "0 objects," Siegelaub's treatment of ideas as discrete, specific forms recreates text within publications as sequenced units of information. A bibliography structures itself through numbers as a means of creating relationships and hierarchies within fields. However, Siegelaub would create such systems even in his day-to-day records; his notepad for the Halifax conference in 1970 begins with numbered events, literally sequenced 1 through 128, and proceeds to a blow-by-blow record complete with time-stamped notations.[7] While chronological, this system is in many ways arbitrary, merely making explicit the already temporal nature of text. Nonetheless, it exhibits a sense of the modular with respect to ideas; numbered in this way, the written thoughts are almost interchangeable, could potentially be alternately sequenced, not unlike Sol Lewitt's patterned squares or, as Siegelaub described Carl Andre brick works, as a composite of "standard elements."[8]

Bibliography

Siegelaub's bibliographic and conceptual art practices encapsulated a sequence of transformations, a daisy chain of one-to-one relationships between text and world, text and text. After his departure from the art community, Siegelaub would write, "Originally, visual communication was attached to a place, and was immoveable.…When the place was destroyed, its visual communication was also destroyed. But while the physical things was [sic.] destroyed, language about it still could talk about, and later could even record it and save it for future generations."[9] For Siegelaub, text served the purpose of abstraction, a means of communicating simultaneously and equally across the space and time both of a book and of a larger geography, charting a Borgesian one-to-one catalog of world events through a logic of "primary information."[10] 📚

[1] The Seth Siegelaub Papers, I.A.44. The Museum of Modern Art Archives, New York.
[2] *January 5-31, 1969* exhibition announcement. Siegelaub, I.A.44. MoMA Archives, NY.
[3] See also: Robert Barry, "The Space Between Pages 29 & 30," eds. Bernadette Mayer and Vito Acconci, in *0-9* no. 6 (New York: July 1969), 29–30.
[4] Seth Siegelaub, *Barry, Huebler, Kosuth, Weiner*, (New York: Seth Siegelaub, 1969), 23.
[5] Seth Siegelaub, *Marxism and the Mass Media: towards a basic bibliography. 1-2-3*, revised ed. (New York: International General, 1978), 8.
[6] Seth Siegelaub, "Interview, April 11, 2013," interview by Michalis Pichler in *Books and Ideas After Seth Siegelaub*, ed. Michalis Pichler (New York: The Center For Book Arts, 2016), 117.
[7] Handwritten notes from October 4, 1970. Siegelaub, I.A.85. MoMA Archives, NY.
[8] Seth Siegelaub, "Seth Siegelaub: April 17, 1969," interview by Patricia Norvell, in *Recording Conceptual Art: Early Interviews with Barry, Huebler, Kaltzenbach, LeWitt, Morris, Oppenheim, Siegelaub, Smithson, and Weiner by Patricia Norvell*, ed. Alexander Alberro and Patricia Norvell, (Berkeley, University of California Press, 2001), 42.
[9] Siegelaub, I.A.108. MoMA Archives, NY.
[10] Seth Siegelaub, "'When You Become Aware of Something, It Immediately Becomes Part of You' November 1969. New York, N.Y.," in *Seth Siegelaub: Beyond Conceptual Art*, ed. Leontine Coelewij and Sara Martinetti (Amsterdam: Stedelijk, 2012), 190.

Urgency

Urgency Print Lab → Artbook @ MoMA
PS1 Bookstore August 5, 2018

→ The smooth flow of network culture has been normalized.

→ Downloading and printing are good interruptions! To slow down the material and the overwhelming condition of flow. Small acts to resist dominant narratives.

→ And so to disperse material, by making it downloadable, is to preserve it—you keep it safe by making copies that disconnect from the network.

→ To download is to counter-publish.

→ Once downloaded, files are outside the conventions and economies and flows of publishing and art. On your hard drive, you're free to do whatever you like with your files.

→ *Urgencyprintlab.pdf* was created on August 5, 2018, and published at 5:53 pm. during a workshop conducted by **Paul Soulellis** at Artbook @ MoMA PS1 Bookstore in Long Island City, New York. This file may be downloaded, shuffled, remixed, printed, re-circulated—even destroyed.

Print Lab

RV_UrgencyPrintLab_PaulSoulellis_Instructions.docx Open with Microsoft Word

artbook.printedweb.org/workshop Urgency Print Lab → A slow web workshop in ten steps. 120 min

1—(Offline warm-up) Take out your device. Set it to not go to sleep.

2—Choose one image from your camera roll to share with the group. 5 min

3—Let's gather the devices together to take a look. 10 min

4—Now, put your devices away.

5—Take some time to think about the images and messages that you've seen recently on the web.

What's memorable?
What's missing?
Who/what do you wish you hadn't seen?
Who/what should be more visible?
What's got value?
What's worth circulating?

Write about images and messages that you wish for. That you wish to exist, or to not exist. Consider your relationship to the web, how you consume, how you share: your habits, your routines, your internet desires and fears. Be as specific as possible. 10 min

6—Now, open your device to access the web.

7—Look for images and messages that you believe should be slowed down and examined more closely. Search for urgent material. It could be a single tweet or photo, or someone's entire feed. Images you want to draw attention to, or deface, or celebrate, or amplify. Make some selections and arrange them on your desktop. Feel free to incorporate your writing, too. 20 min

8— Now let's scan and print! 20 min

9— Cut, tape, draw, write, and collage the printed material onto 8.5 x 11 sheets. These will become the pages of our collaborative publication. 40 min

10—Circulate the URL! artbook.printedweb.org to download our publication: Urgencyprintlab.pdf

artbook.printedweb.org Urgency Print Lab → Artbook @ MoMA PS1 Bookstore August 5, 2018

The smooth flow of network culture has been normalized.

Downloading and printing are good interruptions! To slow down the material and the overwhelming condition of flow. Small acts to resist dominant narratives.

And so to disperse material, by making it downloadable, is to preserve it—you keep it safe by making copies that disconnect from the network.

To download is to counter-publish.

Once downloaded, files are outside the conventions and economies and flows of publishing and art. On your hard drive, you're free to do whatever you like with your files.

Urgencyprintlab.pdf was created on August 5, 2018 and published at 5:53pm during a workshop conducted by Paul Soulellis at Artbook @ MoMA PS1 Bookstore in Long Island City, NY, USA. This file may be downloaded, shuffled, remixed, printed, re-circulated—even destroyed.

Participants:
Kathleen Caliway
Dikko Faust
Esther K Smith
Thomas Jockin
M Wu
Ramona Ponce
Eric Mueller
Olivia Najt
Jackie Leger
Lulu Morfogen
Brian Paul Lamotte
Aayushi Khowala
Tiger Dingsun
Amy Bassin

Participants:

Amy Bassin	Aayushi Khowala	Olivia Najt
Kathleen Caliway	Brian Paul Lamotte	Ramona Ponce
Tiger Dingsun	Jackie Leger	Esther K. Smith
Dikko Faust	Lulu Morfogen	M Wu
Thomas Jockin	Eric Mueller	

EMMY CATEDRAL is an artist working in performance and installation, and makes things with paper, including books. She has also presented work as The Amateur Astronomers Society of Voorhees and The Explorers Club of Enrique de Malacca. She is co-founder, with PJ Gubatina Policarpio, of The Pilipinx American Library, which recently completed a June/July residency at Wendy's Subway, and is currently at the Asian Art Museum, San Francisco. Emmy is the Coordinator of Fairs & Editions for **PRINTED MATTER, INC.**

SHARON HELGASON GALLAGHER is the President and Executive Director of **ARTBOOK** and of **D.A.P./DISTRIBUTED ART PUBLISHERS, INC.** in New York, a publishing and distribution company she co-founded in 1990. Sharon is a graduate of Yale University, New Haven, *summa cum laude*, and holds an MA in Philosophy from Columbia University, New York, where she was a University Fellow.

D.A.P. 's museum publishing clients include the Museum of Modern Art, the Guggenheim, the Museum of Fine Arts, Boston, the New Museum, and the Walker Art Center. Steidl, Skira, Hatje Cantz, and Damiani are among the many international art, photography, and architecture publishers represented by D.A.P. The company also provides distribution for books from numerous small presses including Siglio, Ugly Duckling Presse, and Primary Information.

Over the last 25 years the company has selected, cataloged, publicized, and distributed more than 20,000 different titles on art, photography, architecture, design, and visual culture from the world's most respected museums and international publishers. The company's mission expanded in the millennium with the creation of Artbook.com and Artbook @ retail partnerships such as Artbook @ MoMA PS1, Artbook @ The Walker Art Center, and Artbook @ Hauser & Wirth Los Angeles, to embrace not just distribution, but also retailing and event management.

NICOLE KAACK is an independent curator and writer based in Queens, New York. She is the Dedalus Fellow in the archives at **THE MUSEUM OF MODERN ART**, New York, where she has assisted with archival displays for the museum's upcoming 2019 reinstallation as well as for *Being Modern* at the Fondation Louis Vuitton, Paris. Come fall, she will be the 2018–19 Curatorial Fellow at **THE KITCHEN**, New York. Nicole has been published by *Whitehot Magazine*, *artcritical*, *Art Viewer*, *SFAQ / NYAQ / AQ*, and *Artforum* and has curated exhibitions at CRUSHCURATORIAL, New York, Re: Art Show, Brooklyn, and Small Editions, Brooklyn. She received her BA in Art History and Visual Art from Columbia University, New York, and is currently pursuing her MA in Art History at Hunter College, New York.

MEGAN N. LIBERTY is the Art Books Editor at the **BROOKLYN RAIL**. Her writing on artists' books and the broader landscape of art book publishing has appeared in the *Los Angeles Review of Books*, *Hyperallergic*, *Art in Print*, the *Journal of Artists' Books*, and the *Brooklyn Rail*, among others. She has an MA in Art History from the Courtauld Institute of Art, London, and a BA in English from Dickinson College, Carlisle, Pennsylvania.

LISA PEARSON is the founder and publisher of **SIGLIO**. She has an MFA in Creative Writing from the University of Oregon and BA in Interdisciplinary Studies from the Evergreen State College in Olympia, Washington. Siglio is now located in a barn in the Hudson River Valley, New York.

SIGLIO, a one-person independent press, is driven by a feminist ethos and committed to publishing uncommon books that live at the intersection of art and literature. The singular editorial vision for the press emphasizes uncategorizable, hybrid works authored by renowned as well as little known artists and writers who use the space of the book as a site of primary experience and invite readers to see the world anew by reading word and image in provocative, unfamiliar ways.

In the ten years since Lisa started Siglio in a garage in Los Angeles, Siglio titles have garnered high praise from the *New York Times*, *London Review of Books*, *The New Yorker*, *New York Review of Books*, *NPR*, *Bookforum*, *Publishers Weekly*, *The Believer*, *The Brooklyn Rail*, and *BOMB*, among dozens of other media. Pearson came to publishing through a circuitous route through non-profit arts management and an intense engagement with literature.

PAUL SOULELLIS is an artist, curator, and educator based in Providence, Rhode Island. His work explores experimental publishing and network culture. He is the founder of research-based graphic design and publishing studio **COUNTERPRACTICE**, founder of **LIBRARY OF THE PRINTED WEB**, curator and contributing editor at **RHIZOME**, and Assistant Professor at Rhode Island School of Design.

Activism and

Historically, zines have been taken up by various subcultures as a means to share unfiltered ideas without permission in an inherently low-cost medium. Zine culture is as driven by anarchists, punks, and political protesters as it is by various art communities.

In New York, zine publishers have made their work visible through their dedicated initiatives in programming, education, residencies, and art book fairs. Their unapologetically inclusive approach to publishing fosters resource sharing and the production of artistically and commercially accessible work. In contradicting the notion of the artist or publisher as an isolated studio genius, they create visibility for themselves and their communities through publishing, and in doing so, act as a model to open up the boundaries of traditional publishing practices.

A seminar-style discussion between 3 Dot Zine, Endless Editions, TXTbooks, Interference Archive, and 8-Ball Community has been excerpted here. Led by Femme Mâché, the conversation delves into the influence of DIY publishing in activism and art practice, along with the application of that spirit to community engagement.

Following that discussion, Stefanie Lewin of Young Artist Zine Alliance led an interactive workshop where participants were taught the history of zines as a crafty form of DIY activism. The workshop delved into different zine-making techniques, and has been documented here. 📚

Zine Publishing

Robert Blair and Kurt Woerpel
 TXTbooks
Paul John
 Endless Editions
Michele Hardesty and Greg Mihalko
 Interference Archive
Devin N. Morris
 3 Dot Zine and Brown Paper Zine Fair
Bobbi Salvör-Menuez and Lele Saveri
 8-Ball Community

Pooja Desai and Lilian Finckel
 moderators, Femme Mâché

Pooja: Every single one of your missions now has a community gathered around it. In what ways have you seen your community come together? How has it become crucial to the work you do? What responsibilities do you now feel in continuing your work?

Devin: When I did the first Brown Paper Zine Fair I talked a lot about how you have to look for the artists who aren't represented. They do exist, they just don't know about your open call. So a lot of times I was building my community by doing research, using some of the resources that were brought up here, and finding that these zine makers do exist. Even if I couldn't have them all physically in a space with me, anytime I had an opportunity to have a table I would reach out to them and ship their books in and back.

I wouldn't be able to do what I do without community, seeing as I'm the only person who is part of 3 Dot Zine. For my first Brown Paper Zine & Small Press Fair, MoCADA [Museum of Contemporary African Diasporan Arts] stepped up to say, "Here's an opportu-

Production

nity this weekend, if you want to take it." And they provided support. For the second, the Baltimore Zine Fair, I worked with Kahlon, an agency in Baltimore that does a lot of stuff—parties and different programming throughout the city—and they provided support. We did it at the Eubie Blake Cultural Center, which is a historical black space dedicated to Eubie Blake. For the third zine fair [the second Brown Paper Zine & Small Press Fair], I recently worked with the Studio Museum in Harlem and Barnard Zine Library. Barnard provided us with the space to hold the fair.

Paul John: The fair was really good, Devin. It's always a good time. Community is really important. I guess I've always had community engrained in my practice just by working in a print shop, which naturally is a community. The history of the printmaking workshop I work at, the Robert Blackburn Printmaking Workshop, is incredible in itself. Bob was a legend amongst printers around the world; he influenced loads of people. He started the Printmaking Workshop in 1948, with the artist Will Barnet, and it ran until 2001. That was the majority of his life. He dedicated his life to the print shop as well as sacrificed his own well-being to make sure that the shop ran. It was a space for anybody to come and print. He invited people from all over the world, mostly people of color, and freely offered access and teaching to people about lithography. So my time there really influenced the mission statement and goals of Endless Editions.

TOOK PLACE AT ARTBOOK @ MoMA PS1 BOOKSTORE, LONG ISLAND CITY, NEW YORK, ON SUNDAY, AUGUST 12, 2018.

Endless Editions was always based around sharing resources, sharing skills, and offering opportunities. The majority of people who work for Endless Editions are what we call work exchanges, so everybody who helps out at Endless has resources available to them. They have access to our studio. They get training on design, print, finishing. They get to experience everything that Endless does, whether it's organizing a fair, organizing an exhibition, putting together an artists' book, working with the resident. We talk about money, we talk about life, we talk about renting apartments. We share time together, and that's what happens when you're in the trenches—whether you're working in service, in retail, at a studio—you're together trying to survive. Our motto has always been "we all rise together." So when TXTbooks calls me at 10:30 p.m. asking questions about their Risograph, I'm happy to answer. Similarly, when I'm texting them at 1 a.m. being like, "Can you update the sponsors on our website?" they're happy to help. *[Laughter]*

and

When you go to these fairs and you do them for long enough, it's really this idea of, "the longer you last, the higher you rise." Don't get it twisted, nobody makes money on books. That's just not the reality here. Publishing really is a privilege and we take that privilege seriously. It's a responsibility to us, so when we work with an artist, even if the book never sells, we'll take it to the fair and show it to people and talk about the project, irrespective of who the artist is or what they've done. We hold all of our publica-

tions to the same standard. We put as much attention into every project as we can and we offer free printing for people who are fighting for equality.

Bobbi: It's also been exciting to see how using the internet can be a way to extend those communities, specifically with the zines that 8-Ball was publishing on mental health and self-defense and reproductive rights. They're one-page zines. They cost the least of all zines you can probably make. The PDFs for those are available online, so it was exciting to see people reach out through social media saying, "I got all my friends to come and meet up and we all made the zines together. It took us a while to figure out how to do it but then we did it, and now we're going to give them away for free at our high school."

Lele: I guess for me, the reason that I wanted to have the 8-Ball Zine Fair when we first did it in 2012, was I would go to zine fairs in New York and most were feminist zine fairs, or comic book fairs, or art book fairs. They seemed to be very categorized and I wanted them to be as broad as possible, so I tried to invite as many different types of zine makers to be in the same room.

Robert: As far as the question of community goes, I think it is really important to keep the community open and keep it growing, which a lot of people in this room and in this zine world do. I think one of the most exciting things you can do is work with somebody who has never produced a zine before. People get really

Protest:

Activism

excited about it. Because it's easier to sell that than a large-scale painting. So something important to us is working with people who are just coming out of education or are beginning their art career. Because it's really hard. It's easy to get downtrodden.

Again in the fair scene, what's really nice is that it's not like you put something in a gallery and it's there for a week and then you see what happens after. The fair is very much like, I'm sitting here at a three-foot table, here's a bunch of stuff, and people are coming by. At a lot of these events people are really interested in seeing what's out there, because it might be something they've never seen before. It's fun because you can easily get stuck in this world of not talking about your art very much, and this forces you to do it because people will ask you questions and will be very interested. It helps you formulate your practice. So in my mind just bringing as many people into that situation is what's really important about it.

Kurt: Yeah, being at a table and having the books out and having someone come up to you and just loose their shit over a project you made, just love it—one person doing that feels so much more impactful then anything that you ever get from just posting a picture on social media about that same project.

Michele: One thing I was thinking in terms of how Interference Archive intersects with zines in particular is how it's a way to think about these issues of

community in the past, too. Especially how people who are doing politically-engaged art are often also doing, say, a signature campaign with a grass roots community group. I think it's important to see how artists are doing other kinds of work. Maybe they're a labor organizer at the same time. I think a place like Interference can help you see those kinds of community connections. And they are lived in the present too. There are a lot of artists who volunteer at Interference. There are also people who are tenant organizers, people who are teachers, etc.

and

Greg: I was talking yesterday with another volunteer about this notion of risk-taking and zine-publishing, or making books in general: the idea that you would take a risk to make a thing that's not going to sell. You might not feel like there's a broad market that's going to buy your shit, but you're going to make it anyway because you want to take a risk either visually or on your content. I feel like that's actually an awesome aspect to this group. And that people, like the ones who invited us here, or institutions that are noticing these risks, tend to appropriate or pull it into their museums and galleries.

Bobbi: Something about this question makes me think about how the practice of DIY, which is integral to zine making, is more dialogue-facilitating versus the more institutional transmissions that are one-way transmissions. Which a zine can be too, but when you're handing this zine that you made over to

the person who's going to read it, that isn't just a one-way transmission. It's an open transmission where the person can engage. On the question of risk, I think there are just more variables because they're more alive. There's room for contamination. Room for drama maybe even. *[Laughter]* This idea of an open dialogue, which I think zine making really facilitates, is in turn what supports community and represents something that is generated by community, not just some genius in an ivory tower.

Lilian: On the idea of this ability in the DIY, when we talk about zines we talk a lot about this subversion of power, because we're not owned by a publisher or an editor. In a lot of ways that avoids the risk of censorship in what you're trying to say. Maybe you could speak to how you've found zine making to allow for this kind of freedom of expression in the DIY, and in the dissemination of your practices?

Robert: I think all publishing is political no matter what. Our work is not necessarily directly political but I think the act of it is. If you think about it, publishing is just saying, "Oh, I like this person who's doing this thing and I want people to see it. I want it to get in their brains and see if anything happens or changes. See if something comes of it." To me, that's kind of all that politics is. So even if it's not direct, the action of publishing—of making these things and

getting them out to people, making them accessible—is very political and exciting too, because it lowers any sort of barrier to that role.

Bobbi: I'm just thinking of how claiming the title "publisher," for some of us, is a potentially radical act in and of itself. Because if we're talking in terms of accessibility, sometimes all it means to call yourself a publisher in the zine world is having a printer and letting anyone come in and make whatever they want. That contaminates the otherwise agreed upon definition of what a publisher is and what power that holds. ◈

Zine
Publishing

VERSO

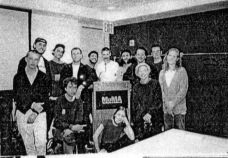

PRINCIPLES OF SOLIDARI

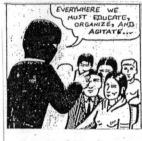

EVERYWHERE WE MUST EDUCATE, ORGANIZE, AND AGITATE...

ALLIANCEZ MUST BE MADE ACROSS SOCIAL SECTORZ...

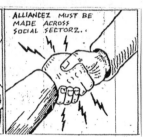

ANTI-REPRESSION

· WRITE THE NLG (National Lawyers Guild) LEGAL HOTLINE NUMBER ON YOUR BODY:

415-285-1011

BLACK POWER

BUILD A CULTURE OF RESISTANCE

· DON'T GO TO ACTIONS ALONE.

1) While engage word and, as far

2) We will remai possible to awak what we see as threatening gest

3) We will not co time offering a p

4) Where we su

5) To maintain o others to bring in

6) We will take r

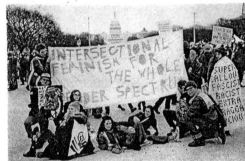

· TRY TO STAY CALM AND SUPPORT EACH OTHER DURING ARRESTS. Remind one another to not talk to the police.

For any inquiries, or to get involved, contact 8ballcommunity@gmail.c

ALL MUNITY

YOUR BODY, YOUR CHOICE; & KEEPING IT THAT WAY.

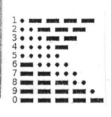

Know Your Rights

The Beginning
of
The End

• DO NOT SNITCH ON EACH OTHER!

...ll with our movement we will refrain from violence in deed, ...ought.

...ents are systems, not people; that our goal is wherever ...e of our cause even while, and by means of, resisting ...fore we will not indulge in abusive language or

...stablishing what we regard as unjust without at the same

...ph over our "victory" or add a fresh issue to the struggle.

...ontrol, we will not bring or, as far as possible, allow

...those who might attempt to depart from the nonviolent

WHAT'S WRONG IN AMERICA

"A Revolution is not a dinner party"

WE NEED YOU!

⑧ TV

IT'S NEVER TOO ⑧

The Future

Capitalism has only existed as the dominant economic system on the planet for a little over 200 years. Compared to the half a million years of human existence it is a momentary blip, and therefore it would be naive to assume that it will last for ever.

Something you wish you had as a kid

ILLUSTRATION BY DEVIN N. MORRIS.

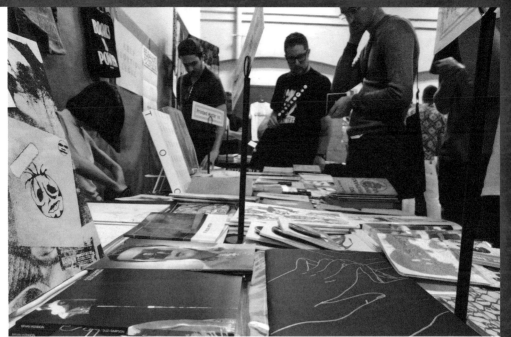

Last year **Endless Editions** began the **Brooklyn Art Book Fair** with Bruce High Quality Foundation, when it existed. For a while we focused on artists' books, and doing a whole lot of art book fairs—we did about forty-two from 2015 to 2017, all over the world—and that's part of our mission as well. Not only to make the books but also to make sure that they get into people's hands. We found the format of an artists' book to be the most responsible way to work in the arts. We felt that it was democratic, it could get into more people's hands, it wasn't like white-wall galleries or art fairs, which are quite intimidating to some people who may not know a lot about art. But books are an intimate experience, so we found the book format to be really attractive for sharing information about art, and also for helping artists' work to get into more people's hands, as well as educating more people about art.

BROOKLYN ~
ART BOOK FAIR
2018 ~
McCarren Park
Play Center

May 25, 6-9 PM
May 26, 12-6 PM

The Brooklyn Art Book Fair was this result of doing all these art book fairs and having this feeling of resentment that they were charging me money to do this. I shouldn't have to pay for this table to exist and I shouldn't have to sell my books just to break even for this event to happen. And so the Brooklyn Art Book Fair was meant to invert that model. Our goals were to pay all of the exhibitors, respect their time, offer them resources where they could not only make money from their publications, but also maybe make a little bit more. So it's free to attend, free to participate. And it's a lot of handshakes and hellos that go into it, but it's all funded from donations. We're not very good fundraisers, so we didn't make that much money, but we were able to pull it off every year through the generous support of a lot of volunteers. 📖

VERSO

No one can
fire you from
your owh
independent
publishing
project...

Have you ever behuld suhc beoute?

A booth you absolutely can NOT
miss i'll tell you what...

Introducing you:

...in theory...

TXTbooks

TXTbooks is an artist-run
independent
publishing initiative in Brooklyn, N.Y.
We work with visual artists
& poets, hoping to provide a cheap
and accesible physical platform for
passion projects and dumb jokes.

Our publications are resolved
via Risograph printing for
cost-effective self produc-
tion and as an informal way
to aestatically bind our output.

txtbooks.us ; Zine Tent A37

Questions you may want to ask yourself
during your production process... (or not)

RE: Content & Structure

Is it for yourself or is it for someone else?
What level of ownership over the final do you want?
Is it driven by a thesis or driven by a process?
Do you want someone to "get" it and if so how long
 should it take before this someone "gets" it?
Is it a thought—cloud or an essay?
Is it active or passive in its delivery?
Is it direct or indirect in its delivery?
Is it a work of art itself or is it a collection of
 reproductions of works?
Is it visual—first or concept—first?
Is it an original work or a response to another work?
Does it stand alone or is it a part of a series?

RE: Form

Should it feel slick or crafty?
Should it feel expensive or cheap?
Should it feel like it was made by a human or not?
Is it color dependent or color independent?
Is it binding—dependent or binding—independent?
Is it bound in a traditional or non—traditional method?
Is it bound at all?
Is it paper—dependent or paper—independent?
Do you want to take your time producing it?
Or do you want to produce it as fast as possible?
Does it need to be as long as you imagine it?
Can it be longer?
Can it be shorter?
Where do you see it living in its finished form?
 A table? A shelf? A wall? A trashcan? The internet?
Do you want people to pay money for it?
Do you want it to last?

WHERE TO GO

for zine resources
 from the participants
 protest and producti
 activism a
 zine publishi

NEW YORK
ART BOOK
FAIR

ENDLESS

ENDLESS

IT'S NEVER TOO
8

IT'S NEVER TOO
8

FEMME
MÂCHÉ

FEMME
MÂCHÉ

INTERFERENCE
ARCHIVE

north-ish

<not to scale>
<not geographically accurate>
<made by femme mâché>

ENDLESS

ROBERT BLACKBURN PRINTMAKING WORKSHOP
copy shop residency
risograph printing workshops

endlesseditions.com
endlesseditions@gmail.com

323 west 39th st, studio 311
ny ny 10018

ENDLESS

BROOKLYN ART BOOK FAIR
may 25-26 2018

mccarren play center
776 lorimer street
brooklyn ny 11222

endlesseditions.com
endlesseditions@gmail.com

PRE-TRUMP ERA TAKE
OVER IN THE L.E.S.
jan 11-22 2017

THE NEWSSTAND
2013-2014 / 2015-2016

8ballcommunity.club
8ballcommunity@gmail.com

38 orchard street
new york ny 10002

lorimer st L-train stop
the museum of modern art

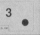

8 BALL ZINE FAIR N°13
june 23 2018

el coqui billiards and lounge
5400 myrtle ave
queens, ny 11385

8ballcommunity.club
8ballcommunity@gmail.com

3

BROWN PAPER ZINE & SMALL PRESS FAIR
june 30-july 1 2018

barnard hall
3009 broadway
new york ny 10027

3dotzine.com
3dotzine@gmail.com

INTERFERENCE
ARCHIVE

open stacks archival collection
workshops, events, screenings,
exhibitions, study center

interferencearchive.org
info@interferencearchive.org

314 7th st
brooklyn ny 11215

independent publishing
cost-effective risograph printing

txtbooks.us
txtbooks.us@gmail.com

119 ingraham st
brooklyn ny 11237

FEMME
MÂCHÉ

CHINATOWN SOUP
curating the zine shop
alphabet soup residency

NEW WOMEN SPACE
bi-monthly workshops
collaborative events

@femme_mâché
hello@femmemâché.com

16b orchard st
new york ny 10002

188 woodpoint rd
brooklyn ny 11211

NEW YORK
ART BOOK FAIR

MoMA PS1
22-23 jackson ave
long island city ny
11101

space, shop, or studio

KEY

recent or upcoming fair

recent install or pop-up

Art, Activism, and DIY:

Zine Making as a Tool for Change

Young Artist Zine Alliance (YAZA) is a free workshop for high schoolers in New York to pursue their art, explore zine culture, and collaboratively create their own zine. YAZA gives teens the opportunity to engage in creative activities, explore various artmaking techniques, express themselves through their art, and meet practicing artists and creative professionals from a variety of career paths who share their perspectives and provide insight into the nuances of the art world(s) and possibilities for the future of young artists.

This opportunity allows teens to connect with other artists, build a creative community, participate in brave space discussions, and to display a final zine exhibition at the conclusion of the program.

YAZA is an alliance of art educators, students, and professional artists, all coming together to find our voices through art, and dream big to follow wherever art takes us.

In line with this participatory ethos, YAZA educator **Stefanie Lewin** led an all-ages workshop of fifteen participants that encouraged activist thinking and focused on techniques for making zines and disseminating this populist mode of publishing.

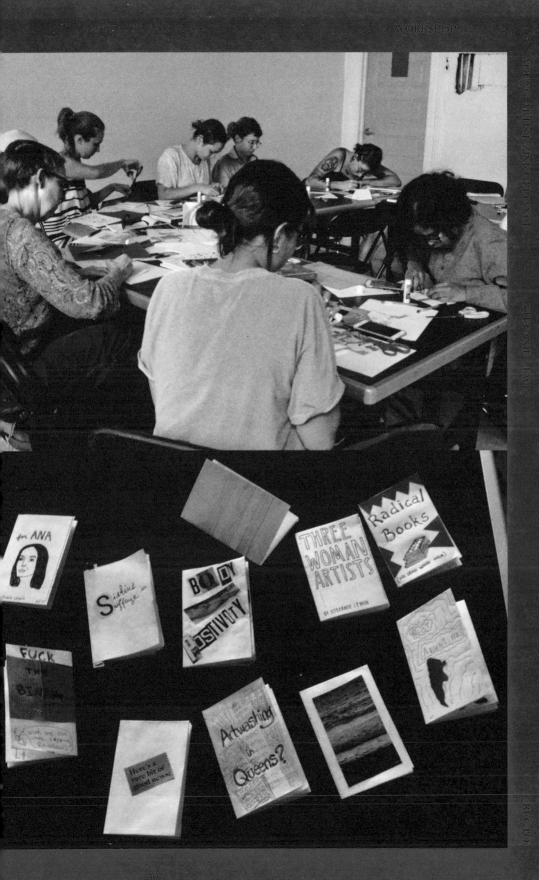

8-BALL COMMUNITY is an independent not-for-profit organization that—through free, open-access platforms and events—nurtures and supports a community of artists. Founded by **LELE SAVERI**, they provide virtual and physical meeting sites for people of all ages, genders, and backgrounds. Their mission is to generate collaborative and educational exchange through public access television and radio stations, an imprint, a self-publishing fair, a public library, an internship program, a residency, and series of workshops in art-related trades. 8-Ball Community operates free of elitism and is governed by its participants. **BOBBI SALVÖR-MENUEZ** is an active member of 8-Ball Community.

FEMME MÂCHÉ is an art collective and programming series founded by **POOJA DESAI** and **LILIAN FINCKEL**. Committed to inclusivity, intersectionality, and exploring all forms of identity, Femme Mâché is in residence at **NEW WOMEN SPACE**, where they hold collaborative zine workshops. In 2017, Femme Mâché created the *Zine Wall*, a permanent installation and zine shop supporting local zinemakers, at the non-profit gallery **CHINATOWN SOUP**.

INTERFERENCE ARCHIVE explores the relationship between cultural production and social movements. This work manifests in an open stacks archival collection, publications, a study center, and public programs including exhibitions, workshops, talks, and screenings, all of which encourage critical and creative engagement with the rich history of social movements. As an archive from below, they are a collectively run space that is people-powered, with accessibility for all. **MICHELE HARDESTY** and **GREG MIHALKO** volunteer at Interference Archive.

PAUL JOHN is the Risograph Studio Manager and teacher at the **ROBERT BLACKBURN PRINTMAKING WORKSHOP**. Additionally, he has taught, lectured, and led printmaking workshops at The Museum of Modern Art, The Metropolitan Museum of Art, The Museum of Art and Design, The Queens Museum of Art, International Print Center of NY, Pioneer Works, and many other institutions and venues.

Paul is the Director and Co-founder of **ENDLESS EDITIONS**, a publishing and curatorial initiative whose mission is to produce and disseminate books and prints by emerging artists irrespective of age, gender identity, race, or creed, and whose books are in the collection of many major museums. Endless Editions participates in all major art book fairs and hosts the **BROOKLYN ART BOOK FAIR**, founded in 2017.

STEFANIE LEWIN is an educator, artist, and illustrator based in Brooklyn, New York, focused on social justice and equitable access in arts education. She holds an MA in Art Education from the City College of New York and a BA in Art/Art History and Psychology from the College of William and Mary. In addition to her full-time position as Education Manager for **ESS COMMUNITY PROJECTS**, a non-profit art studio in Greenpoint, Brooklyn, she lectures and teaches workshops at venues around the city. Stefanie has previously taught at the Whitney Museum; Creative Art Works; a public high school in Baltimore, Maryland; City Art Lab and **YOUNG ARTISTS' ZINE ALLIANCE**, two free programs for teens at City College; and Free Arts NYC.

DEVIN N. MORRIS is a multidisciplinary artist based in Brooklyn, New York. He is interested in the emotional presence of objects and abstracting black American life through his exploration of memory, familial duty, and sexual identity in photography, video, collage, and writings.

3 DOT ZINE is an annual publication created and edited by Devin, which serves as a forum for invited artists to center and elaborate on marginalized concerns. Devin's frequent invitations to participate in zine fairs with *3 Dot Zine* led him to realize the lack of black and people of color representation in the field. As he found the fair marketplace environments to be encouraging and vital to community building, he organized the first **BROWN PAPER ZINE & SMALL PRESS FAIR FOR BLACK AND POC ARTISTS**, an event where the creative efforts of artists of color working in self-publishing and printed media are exposed and proliferated.

TXTBOOKS is an artist-run independent publishing initiative in Brooklyn, New York. They are interested in self-publishing as a collective while facilitating projects with outside artists and writers. TXTbooks' best-case scenario is to publish those who have not yet considered producing a zine; their ultimate goal is to create dumb jokes and passion projects with as many people as possible. TXTbooks publications are resolved via Risograph printing for cost-effective self-production and as an informal way to aesthetically bind our output. The collective was started by **ROBERT BLAIR**, **THOMAS COLLIGAN**, **NICHOLE SHINN**, and **KURT WOERPEL** in 2014.

Artists' Books

Artists' books honor the ubiquitous age-old form of the book by conceptualizing it as an artwork in its own right. Rather than documenting a project or practice and looking at the book as an inherently representative creative form, artists' books and artist-run presses do the boundary-pushing work of approaching the book as three-dimensional work whose production and physical form is as relevant as the content it contains.

The unifying quality that connects artists' books to traditional publishing is an emphasis on distribution and multiples. Artist-run presses are no longer defined solely by their traditional fine printing and binding craftsmanship, but are also interacting with global culture through digital platforms for distribution, further engaging with the question of how we define a "book" and what that form has the potential to contain and become.

This chapter spotlights the pertinent work of four artist-run presses and bookmakers—**Cooperative Editions, Nontsikelelo Mutiti, Peradam Press,** and **Small Editions**—as they discuss the ways books function as art objects and how that methodology informs the creative process behind bookmaking and publishing as well as the politics, practices, and ideas that drive projects.

Putting that framework into action, **Celine Lombardi** of the **Center for Book Arts** hosted a workshop that taught participants how to make numerous book structures for self-publishing art and writings, exploring variations on the pamphlet and accordion book. 📖

and

Artist-Run Presses

Sam Cate-Gumpert
and **Elizabeth Jaeger**
 Co-founders of Peradam Press
Nontsikelelo Mutiti
 Self-publisher and Graphic Designer
Nicholas Weltyk
 Publisher at Cooperative Editions

Corina Reynolds *moderator*
 Director and Co-founder of
 Small Editions

Corina: I was really trying to think about how we can talk about the topic of this panel, "Reimagining the Art Object: Artists' Run Presses and Artists' Books," It's a really big question in publishing. To think about the history of the book as an artwork, there's so much that has been done in the last forty years it almost seems like there's not a huge amount of space to make innovation. So thinking about how the book as an artwork relates to the book as a cultural object, and how they interact, I think it would be nice for us to talk about our practices and how that relates.

Nontsikelelo: We can all make books in so many different ways and I don't think that we have to think about innovation in terms of material and process and design necessarily. For me the most important thing is what those objects are doing. Artists' books tend to have a very niche audience. But for Black Chalk [Nontsikelelo and Tinashe Mushakavanhu] we're really interested in getting the work into the hands of people on the street level—there must be street value.

When I started out in graduate school, my primary concern was to make objects that anyone who touched could feel like they could replicate. They were all on very cheap paper, they could all be xeroxed, made at a copy shop with standard sizes, spiral bound or stapled. We have also done much more precious objects. We finished a book in January that is cloth-bound, foil stamped, much heavier on production value. For me, innovation is about how these objects operate, what the audience is, where the community is.

Corina: I think that's a really good point. I'm curious, Nicholas, your editions often are a lot smaller than what Nontsi's making. Sometimes an edition of fifty. Or what's the smallest edition size you've worked on?

Nicholas: Maybe a few more than ten? But usually closer to one hundred.

Corina: I'm curious about the way you see books like that interacting. Because, Nontsi, it seems like what you're talking about in relation to the innovation of books is really tied to distribution. And when you make an edition of ten, which Small Editions also does, the audience is very different.

Nicholas: I could probably count on two hands the number of stores that carry the books. So doing the fairs and meeting the people buying the books is really fun. I do appreciate the sensibility you're describing, where someone could see something and think it's something they could reproduce themselves. It isn't necessarily so precious.

Nontsikelelo: Publishing is so interesting because of the different roles involved—from editing to choosing paper

stock to writing to creating or sourcing images. Then it has to be printed and bound, and that time has to be respected, and the resources maybe are precious. Maybe you can't make more than ten or maybe it's important to only have ten. So even though we're working with street value doesn't mean that's it's a throw-away or cheaper. If you're working with ten, it doesn't mean that you're not considering an audience. Maybe that precious object is meant to be viewed in a static place and people come to it. I think as we continue working, these formats are things to really consider: the very precious book, the standard format, the xeroxed versus the really elaborate binding methods.

Nicholas: I agree. When you make ten or one hundred books it's often the case that you've touched every book, or hand-trimmed every book, or some-how they've passed in front of your eyes and you do want to know the person that you hand that over to. But I've also given away a book and then seen that person toss it in the trash. Or I've given a book to someone who I work with and admire, and I came over to his house and he was not using it as an ashtray, but like... a spot to roll up weed. *[Laughter]* Of course that's not to say that he didn't read it, but I do like making things that feel like they're affordable but they are still precious, like you're getting something nice for what you're spending. But still, you have to know that even that person you interacted with, even that book—it's not so special, it's not like a $100 book you have to keep on your shelf and can't pull out. You could use it as an ashtray or toss it out.

Reimagining

Corina: That's reminding me, I went to this talk last night at the Swiss Institute by Ken Liu titled "The Bookmaking Species," and he went through the history of books, from cune-iform tablets up to scrolls and codices into ebooks, and he was making this argument that a lot of the books that we have as cultural objects now exist in their particular format because of the commercial aspects of the object. The fact that they need to sit on a shelf and be sold. And because of that the object of the book in certain places can lose its value. So I think what you're talking about, your friend using the book as a weed-rolling station, is kind of indicative of that. Is that something that you guys have experi-enced? *[Laughter]*

Sam: I'm sure that people are using our books to roll weed. *[Laughter]*

Elizabeth: As an artist, I think a lot about how for musicians, you have a concert, and there are records and all of your fans can buy a piece of your art making for $15, $20. And then they have this object that is representative of a community. And I was like, "Oh, I can't really do that with sculpture." Even the cheapest thing in a gallery is still over $1,200, and that's not accessible.

But you can do that with art objects. We made copies of Mary Manning's book or Linda Simpson's photos and

the

people can buy them for $15 or $20 and have an art object at home that's a part of this community. Whereas otherwise it would just go to the gallery where most people can't afford to own those artworks. They might take an iPhone photo and own that part of it. Alexis Penney demanded we make her an ebook, which we did. But you lose something without having an object that links you to other people in this way: we've touched each of these things that now other people are touching and it's like, a more or less finite number of people that are engaged with it and can pass it on. Whereas with an ebook, your computer dies and it's nothing.

Nontsikelelo: Even though an ebook can be shared with many more people, depending on what sort of platform this object exists on and whether there's a monetary value attached to it?

Elizabeth: Yeah, I think having a book, an object that can be handed over, it's like gift exchange. That is much more powerful then receiving an email of an equally important book. All of the college essays that I scanned, I don't know where they are, but I have a bookshelf with every zine I ever received from a person. That's the history of a community I'm part of.

Corina: But here's a question, and I bet this has happened to all of us: how many of you have maybe purchased a book or received one as a gift, an art book or a zine or something that somebody actually made, that you looked at once and haven't looked at again?

Sam: I have books that are still

wrapped. And there's the fetishized object component of this. A lot of us love books, but we also know that some of these books may accrue value. And that tension between wanting to engage with the object and the work that the object contains, but also wanting to maintain whatever limited form of value that object accrues, is tough for people—certainly tough for me.

One thing we also touched on is the question of control and distribution. One of the reasons we stopped printing by hand was exactly what Nick was saying: we wanted to be able to give books away. When we printed and bound them ourselves, we only had ten, fifteen books. The flip side to that is the secret to arts publishing in general, that distribution channels are few and far between, especially in the United States. They're tough. It's a money-losing business. It's not really a business at all, considering it very rarely makes money. Corina, I'd love to hear about your business. You seem to be the success story on this panel.

Corina: My model is very different from the way that a lot of other people publish. A lot of art publishers start out making things by hand because they can't afford to print it at a larger scale and give it to everyone they know. We produce things in small editions and we're able to do that because we actually do production work for people. Our publishing is just barely sustaining itself financially, but it's definitely propped up by a completely different leg of what we're doing for other people.

When I think about the distribution of an artists' book, instead of the demo-

cratic multiple idea of distribution, where you're taking one book and you're handing it to somebody until you've reached 1,000 people, what I think about, especially with our smaller editions, is how they can find an audience in a library. We recently made an edition of three, it's beautiful; it had to be an edition of three because it's so hard to print, it just wouldn't be possible to make a thousand. The thing that's really exciting for me is to see that go to a university collection where a librarian is going to share it with students over and over and over again and use it as a tool for talking about the form as an artwork.

Nontsikelelo: I think that's so important, that these objects can inform the works of other individuals, that they are not vacant of content, that they can also be places for study and things that can support other people's research.

I want to jump back to this ebook thing. I'm the Zimbabwean here, so I'll just speak as it. Infrastructures are different everywhere, even within the United States. So for me as a practitioner, making artists' books and selling them at book fairs and then having to carry all that paper to Zimbabwe is not feasible. Right now we have this panel and I've just come from this long trip and all my books are in Richmond. How do you transfer all of that content? And who is the content there for? Does it matter if they're flipping through the paper pages? I think digital media gives us an opportunity to think about what other kind of media and image-making is possible, where the time-based can meet the static text, or where text can be moving, where there can be audio.

Art

We all print a certain number of copies here, a certain number of copies in Zimbabwe, but there's a bigger audience than that.

Of course, everyone's practice has its own values, but I'm very excited about these mechanisms that allow something to travel very, very, very far, very, very, very quickly. In the US, things go viral on Twitter or YouTube. In Zimbabwe, things go viral on WhatsApp. People can't access the internet on laptops because not everybody has a laptop, but most people have smartphones, so we're even thinking how can some writers, poets, be disseminated through WhatsApp messages, through images that people can send to each other on these sorts of platforms. So this idea of distribution, for us, we really consider what mechanisms people have. We're really interested in moving away from anything that's going to make it harder for our audience to access the material.

Object

Elizabeth: We're in a day and age where people have their phones, and over time, through WhatsApp or Instagram or Facebook, everyone can record something, everyone can do live videos. Recently I was asked to do an interview for a magazine and I ended up saying no. The next day I saw someone did an "ask me a question" thing on Instagram, and it was actually a really in-depth interview with the artist, and it's like, oh, why do we have a magazine? Why do we have publishing when we're in this space where all information can be disseminated so easily and things do go viral?

Books

Artists'

Nontsikelelo: The everyone and everything is always a very scary rabbit hole to go down, a black hole even. But you are right that these are other ways to publish. I think the thing that makes an artists' book or art object is the attention and the conceptual rigor behind it. When we talk about the PDF, all of these things—the fake page turning thing—I don't think that the space of electronic media can ever be able to mimic what's happening in the tactile form. We are all more versed on this panel in terms of ink and paper and we have a lot of possibilities there. Those things also have their limitations. I'm getting more interested in what the limitations are on the screen. My phone is in my pocket like I could put a book in my pocket. I'm not a tech geek but I also know the limitations of the space that I come from and so it's forcing me to have to consider what technology or other forms can offer.

Elizabeth: Yeah, and also to add on from earlier, the schlep is real and it sucks. It's prohibitively expensive most of the time. How do you get enough books to disseminate over borders with taxes and shipping costs and luggage fees? We had to carry our books here, and it was hard. *[Laughter]*

Sam: It also prevents people from doing the fairs. After the cost of paying for the table, and airfare, and shipping books, breaking even is rapidly out of your reach. It becomes a money-losing proposition and I think the longer people do publishing groups or presses the more disenchanted with the process they get.

Nontsikelelo: Is this something then we're not thinking about as people who are producing these objects? I've been at fairs and thought to myself, "Oh, we all have different ways of getting the books here and none of us seem to have it down right." Why aren't we sharing resources and ideas? Why are we even making these heavy things that we know we're going to show at fairs? Is there something that we're not getting? Why are we stuck on this thing?

Sam: We're stuck on this old model of what the book is and I don't necessarily want to break out of it. I still love the heavy-duty art book that you can't print on-demand. That has to be printed abroad in multiples of 1,000 or 10,000. But I think that, to your point, we're still in that model and trying to balance these things.

and

Brian Paul Lamotte, who's designing the *Recto / Verso* book, printed a book just recently in India that is photos of bootleg knockoff products that was printed by a bootleg knockoff printer and bound in India. I think something like this is akin to what you're talking about. I think there are projects that could be printed on demand in different places or could be printed differently to match the tone or the tenor of the city that they're being printed in.

Artist-Run

Corina: I like what you were starting to talk about that maybe we should be sharing resources, whether it's production resources or, for instance, even galleries are sharing their art shippers when they're going to fairs. I don't know why we aren't doing that. Have you guys ever done that?

Sam: We have, yeah. We will work with people who are printing abroad and will combine our shipments, which definitely helps, but that really takes a lot of work to coordinate.

Elizabeth: Or printing in the place where the work is going to be presented. I don't think we've used the same printer more than twice, just based on what the project is.

Corina: We're talking a lot about distribution, about printing methods and object specificity. And I think there's something really interesting about the ways that these parameters can push our publishing practice, like what you're talking about with only producing something in another country or only producing something with a certain technique because of where it needs to go.

Audience Member: Going back to talking about the preciousness of books, do you find that artists' books are defined by this idea of preciousness, as opposed to a zine or pamphlet? What matters more in that sense, the content or the form?

Sam: What I would argue for artists' books, as a working definition, is flexibility. The ability for a book to not necessarily be locked in to the traditional format of a book. We all touched on the manner of a book's printing and whether it fits the project and the content. I think this matters more than whether or not it exists as a zine or as a card or as a perfect bound book or staple bound book. What matters is the way that it's printed, and this could mean that it really does have to be printed differently every time it's printed or in every country it goes to or every fair it appears at. What matters is that there's a coordination between the printing and the content.

Corina: I totally agree. ◈

Cooperative Editions
www.co-ed.us

Mary Manning: First Impr

Maia Ruth Lee: Paintings of Illustrations of Women at Work

Mary Manning

Ann Greene Kelly: In Touch

Sarah Elliott: A-I-M-E-R:

Alexis Penney: Window

Aidan Koch: Impressions

Aidan Koch: Impressions

Amanda Friedman: Because Nothing Ends

Juwelia Soraya / Stefan Stricker: Juwelia : Paintings

Aidan Koch: Impressions

id Knowles: Come/Closer

Bonnie Lucas, Young Lady

Linda Simpson, Pages (pictured: Page Reynolds)

Linda Simpson, Pages (pictured: Page Reynolds)

Ann Greene Kelly: In Touch

Because Nothing Ends

Hagen Verleger, ed.: Margaret van
Eyck – Renaming an Institution,
a Case Study (Volume One:
Research, Interventions,
and Effects)

Ann Greene Kelly: In Touch

Binding for

Self-Publishing

On August 14, 2018, over twenty-five participants congregated at Hauser & Wirth Publishers Bookshop, where **Celine Lombardi** of the **Center for Book Arts** taught methods for creating three simple book structures:

Pamphlet Binding with Paper Wrapper

The simplest bookform is the pamphlet binding: a group of pages are folded in half with a heavier paper cover folded around them. Sewing goes through the pages and cover at once. A wrapper, though not necessary, can make the book look more finished by hiding the thread and giving the opportunity to fold a square spine to make space for a title. Many poetry chapbooks are pamphlet bindings.

Drumleaf Binding

An excellent structure for artists' books, photography books, or any instance when the page can only be printed on one side: single pages are folded in half, stacked with the folds all lined up neatly and square; the individual pages are adhered using either glue or a double-sided adhesive at the spine edge and the fore-edge of each spread. The resulting book opens flat and has a sleek modern look with no thread to interrupt the images. A paper cover can be wrapped around to finish the book or it can be cased in a hardcover. A variation is the butterfly binding where the pages are adhered at the fore-edge but the spine is left free.

Hardcover Accordion Binding

This sculptural bookform is a dynamic choice for artists' books. The pages can be double-sided or not; the final book can be displayed standing open, hanging, or read by turning the pages as if a regular book. A long strip of paper is folded into an accordion with pages of equal size. The covers are made of bookboard cut to the same size as the folded pages and covered with decorative paper or cloth before being glued directly to the first and last pages. ◈

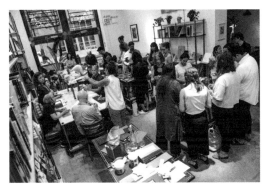

CORINA REYNOLDS is Co-Founder of **SMALL EDITIONS**, an artist book studio that publishes and supports the creation of new contemporary artists books, and Interim Executive Director of the **CENTER FOR BOOK ARTS**. Her passion for the art of the book has led her to teach workshops and classes in independent book publishing and bookbinding in the US and abroad. She has curated exhibitions of both artists' books and contemporary art, organized panels on contemporary artist books, and lectured about the bookworks of Small Editions and other artists. She holds an MFA from Cranbrook Academy of Art, Michigan.

SMALL EDITIONS is an artists' book publisher and curatorial residency program in Brooklyn, New York. Its primary mission is to expand our understanding of the artist's book by engaging with artists through studio visits and conversations, publishing artists' books, and inviting curators, artists and the public to interact at its Brooklyn location for exhibitions, lectures, and the appreciation of artists' books.

CELINE LOMBARDI studied bookbinding at the North Bennet Street School in Boston, Massachusetts and through working with private bookbinders in New York. Currently she is a core bookbinding instructor at the **CENTER FOR BOOK ARTS** in New York; is the Chair of **THE GUILD OF BOOK WORKERS, NEW YORK**; and has her own private studio in Brooklyn, New York. Her fine bindings have been exhibited in Boston, Chicago, London, and New York. Her artist books are in rare book collections of libraries across the country.

The **CENTER FOR BOOK ARTS** promotes active explorations of both contemporary and traditional artistic practices related to the book as an art object. The Center seeks to facilitate communication between the book arts community and the larger spheres of contemporary visual and literary arts, while being a model organization locally, nationally, and internationally within the field. The Center achieves this through exhibitions, classes, public programming, literary presentations, opportunities for artists and writers, publications, and collecting.

PERADAM PRESS is a publishing group specializing in small-run artist books. Each book is designed and produced in collaboration with the artist. Peradam is owned and operated by **ELIZABETH JAEGER** and **SAM CATE-GUMPERT**. (Peradam: n. An object that reveals itself only to those who seek it.)

COOPERATIVE EDITIONS (CO-ED) is a name under which **NICHOLAS WELTYK** offers friends, artists, and authors assistance in the conceptual development, graphic design, production, and distribution of books and printed matter. Since its commencement in 2013, Co-Ed has published roughly twenty titles. For the duration of spring and summer 2018, the shared office of Co-Ed and Common Satisfactory Standard hosted Gallery Co.Co.—a group show of seven artists and seven artworks presented bi-weekly, one piece at a time. Early in 2017, the two presented Book Locker, a temporary bookstore highlighting twelve New York–based publishing projects.

NONTSIKELELO MUTITI is a Zimbabwean-born interdisciplinary artist and educator. Nontsikelelo holds a diploma in multimedia art from the Zimbabwe Institute of Vigital Arts and an MFA from the Yale University School of Art, with a concentration in graphic design. Recently, she has been a resident artist at the Museum of Contemporary Art Detroit as well as Recess and The Center for Book Arts, both in New York. In 2015 Nontsikelelo was awarded the Joan Mitchell Foundation Emerging Artist Grant in its inaugural year and has participated in several group shows at venues such as the Studio Museum in Harlem, the Whitney Museum, the Metropolitan Museum of Art, and We Buy Gold. She is currently Assistant Professor in Graphic Design at Virginia Commonwealth University.

Nonprofits,

Institutions and galleries have long been the driving forces of traditional art publishing through the practice of producing exhibition and collection catalogs. The large-scale, glossy pages that make up these books are often filled with seductively-reproduced images and comprehensive essays that are fundamentally appealing, acting as powerful visual objects as well as tools providing insight into artists' practices.

Institutions,

Increasingly, the landscape of this type of publishing has become more nuanced with the rise of nonprofit and digital publishers who often come to independent publishing with alternative forms of distribution, funding sources, and content generation. These approaches offer institutional publishers new models to experiment with, while simultaneously expanding the field of established contemporary publishing practices.

In the first section of this chapter, **Hauser & Wirth Publishers** facilitated a discussion with leaders in each of these forms of publishing that focused on the way institutional missions—the goals of galleries, museums, and other established print and digital publishers—influence the process of publishing itself. Panelists from **e-flux journal**, the **Metropolitan Museum of Art**, the **Museum of Modern Art**, and **Rhizome** explored how art publications become vehicles that accomplish what these institutions set out to do, and how these publications exist independently from the programs and spaces for which they are created.

Galleries,

The next section offers the transcription of a second panel featuring several nonprofit publishers, including **The Drawing Center**, **Pioneer Works Press**, **Primary Information**, and **Printed Matter**, moderated by **Sharon Helgason Gallagher** of **ARTBOOK | D.A.P.**

Their conversation delved into the value of independent publishing, organizing and attending art book fairs, and creating models for sustainable publishing practice. ◈

and the Web

Kaye Cain-Nielsen
Editor-in-Chief of *e-flux journal*
Zachary Kaplan
Executive Director of Rhizome
at the New Museum
Hannah Kim
Business and Marketing Director
for the Department of Publications
at The Museum of Modern Art
Mark Polizzotti
Publisher and Editor-in-Chief
at The Metropolitan Museum of Art

Jake Brodsky *moderator*
Editorial Assistant
at Hauser & Wirth Publishers

Jake: I would be interested in exploring a theme that crops up in a lot of the missions of the institutions that you all are affiliated with: the question of accessibility. Either just in their *raison d'être*, like a museum being a hub for education, or *e-flux journal* being this place where you can access ideas that have potentially gone by the wayside, or Rhizome, which is about giving this accessible platform to things that might live elsewhere but also aggregating them in a certain place. How do you think about accessibility in terms of design, but also distribution— books, different media, PDFs—those sorts of things?

Mark: We are all about accessibility. There are two major strains of publishing at The Met. One of them is print, and we try to address the question of reaching an audience by the content. I'm a firm believer that anything can be made accessible to a reasonably-educated, interested audience as long as you bring that audience along. This means not assuming a lot of specialized knowl-

edge from the start. In terms of packaging and the design, we try to make the book visually appealing in a lot of ways. We try to craft a design that's appropriate to the subject. Obviously a book on medieval Armenia is not going to get the same design concept as a book on contemporary conspiracy art—both of which we're doing this fall.

Our online publishing platform, Met Publications, started as a way of putting some of our out-of-print backlist titles back in print when there wasn't enough demand to reprint them in physical books. We digitized everything as searchable PDFs, and we have a print-on-demand function, so it can be distributed in any number of ways and it's completely free—the print on demand books you do have to pay for but we don't actually make any of that money, it's simply the out-of-pocket cost. You can access them for free online, you can print them out on your computer, you can do whatever you want.

On top of that, we found a wonderful way to publish things like collection catalogs, which are part of the heart and soul of what any museum does, but a nightmare when it comes to publishing, because by nature, they're outdated when they get printed. Nobody wants to pay for them, so we have started to publish a number of our collection catalogs digitally.

The first one we did is on sandstone sculpture and is a book that, had we printed in the traditional way, we might have sold 400 or 500 copies of over a number of years. In a very short time, this one had something like 6,000 down-

loads, and this professor wrote us to say that he had assigned it to his class. So this, to me, is getting to exactly the audience that we had aimed for and doing it in the best and most direct possible way.

Publishing

Jake: Which is an interesting approach when it comes to both accessibility of the medium and its content. *e-flux journal* is similarly accessible, in this almost open-source format, but, Kaye, one might think a reader comes to the journal with a certain background. How do you navigate the question of the accessibility of the medium, but also maybe the sometimes-challenging nature of some of the content?

Kaye: It is something that we talk about: how do we make this accessible if someone doesn't have a philosophy background? I don't have a philosophy background, so having an editor who isn't a specialist helps. I also think there's such a wide range of topics that are covered, whether it is different discourses in contemporary art or academic disciplines that come together in the journal. There are different parts that people from different backgrounds might latch onto or be able to access more. Certainly it is interesting, having a very open-source, free online thing. Although to an extent it is self-selecting in terms of readership and I wonder how to make that more accessible. So much of our readership and authorship also don't speak English as a native language. How can we make it really understandable if somebody is

in

reading this and they don't have as firm of a grasp on English?

One thing we're also trying to do with the different partners we work with is to find different themes or niches for different publishers. Verso Books has excellent distribution, so a lot of people who might not have seen our Sternberg Press books might have seen those. The hope is through University of Minnesota Press or MIT Press these books might be more accessible at educational institutions.

Zachary: As in any specialized field, our field is mired in work and writing that has a high barrier to entry. Even with printed art publications about net art, for example, a lot of them have very high prices or may be out of reach in terms of the discourse. We feel a real responsibility to publish accessible writing that's primarily about specific artworks and dives deep into those artworks, usually through an oral history that is conducted by a curator, or a critical address that is fact-based. We also have a small series that gets very little readership and circulation besides the CVs of the artists who receive them, called *Artist Profiles*. We do short interviews, mostly with early-career artists working primarily with digital tools and networks. It is really important work, because it's usually the first thing on their CV or the only writing about them, and it meets a real need that other publishing infrastructure isn't meeting.

Spaces:

The other thing I just want to mention is that, # Institutions, up until I became Director in 2015, web visitor statistics were something that were brought to a board meeting and were considered as a kind of metric and I felt like I had to end that, recommitting Rhizome to publishing that was infrastructural and about supporting digital art and net art in ways that it actually needs support to grow an audience, and less about an arbitrary number defining its kind of broadness.

Jake: What has the relationship been like working as publishers in relation to an institution where you do have to explain, for example, that visitorship doesn't have everything to do with web publishing for Rhizome, or maybe that you're reevaluating the metrics because The Met would have only sold 400 copies of that sandstone sculpture book? How do you come at the publishing practice and present it to the institution that is backing you?

Mark: For us, one of the big challenges is figuring out where that line is between our existence as a publisher, the publications department, and to what extent we bleed into the larger life of the institution. We tend to think of ourselves as an independent publishing entity within the larger context of The Metropolitan, but if you ask a lot of the curators, we're there to serve the educational or curatorial mission.

That can be a bit of a tension, because my feeling is that our department's primary allegiance is to the book, to the object we are crafting. Also to the audience of that book, which is not always the same as the curators or authors feel is their primary allegiance, because for them it is often to their colleagues, their peers. So for us to try to build in that accessibility, or to design the book in a way that also has a certain trade appeal outside of the museum, some of them absolutely get it and are completely on board. Some take it as a challenge to their way of thinking.

The phrase that we always hear all the time is "dumbing down," which is not at all how I see it. It's not necessarily a given for a number of stakeholders that trying to make something accessible does not automatically mean dumbing it down to a level that makes it uninteresting. To me it's the complete opposite: it makes it more interesting.

Hannah: I think MoMA's experience is probably close to The Met's. When we ask our authors and curators who their target audience is for their book, they always say the general museum audience, which is funny because that can be anyone: international visitors, students, families coming for the first time. One advantage of having a physical location is to see the people who come to the museum and to say this is our audience: What do we have for the students? The scholars? The visitors who just want a MoMA souvenir? The people who are slightly interested but don't know a lot about modern art? What can we offer them that's inexpensive and very accessible? For kids, as well, how do we explain some of these concepts of modern and contemporary art to them? It also helps to have a very good education depart-

ment that is always reminding us that we need to, not dumb it down, but think about accessibility from a public-facing perspective and not just the internal MoMA-author-curator circle.

Zachary: When it comes to publishing, we are fully independent, as opposed to other programs that are much more embedded in the overall museum programs. We made this choice to focus on infrastructural need, on accessibility, on a variety of more kinds of basic tasks that the field needs and is lacking.

We are in the midst of working on a print publication that has been really exciting to define because it's about net art and net art history and it relates to online projects. You have all these really interesting publishing concerns, like how do you make something that relates to content that is freely available online but is different and expresses itself in a unique way that only print can? So we're working with the designers and a trade publisher to produce it while keeping the price incredibly low, so it can be like student-level pricing. Or like, what is the definitive way to screenshot a net art work? What matters to the artist in how something is captured when it's going to be flattened into a color picture on the page? For anyone who's going to be publishing a net art work in a book, please include the browser window—it's very important to understand what something is and how it's interacted with. But yeah, I would say we're very independent when it comes to publishing within the New Museum's overall program.

Jake: To go back to what Kaye brought up with regard to phrasing content in certain language, I think an interesting thing about what Rhizome does with net art is present it in the context of the work's medium, which also relates to institutions, like MoMA and The Met, where one could say that you are very much working in a tradition where it has been defined how these spaces translate into these books. How do you navigate a work's relationship to its immediate context in relation to the more established pathways of representation?

Mark: The established pathway is really the tricky part. The reality is, if you are standing in front of a monumental sculpture, there's going to be a certain grandeur to it. There's going to be an aura. You're looking at this wonderful thing, and it has contour and shape and size, it has all these things—presence. Now I've got two dimensions and four colors and somehow I have to try to translate that experience of the power and the potency of the work of art onto the page.

I always have to remind the curators, the people we work with, that we don't publish art, we publish pictures of art. It's not the same thing as actually looking at the work itself. It's a representation. That means that you're working in a very, very different medium. Books have advantages of their own that the art actually doesn't have: we can bring up all kinds of things about it, we can talk about it, we can frame it within a context, we can use lighting to photograph it in an interesting way,

Galleries,

we can use book design to create a really pleasing spread on the page, we can use packaging and binding materials to make this wonderful 3D object. There are things that are wonderful about a book that you will not get from walking into a gallery.

Zachary: I wanted add one other thing that I saw in a book recently that caught net artwork really well: HeK in Basel produced this really lovely publication all about Olia Lialina's *My Boyfriend Came Back From the War*, which is a seminal early internet artwork and just an incredible piece, but it's from 1996. There were a number of beautiful install views of the work in a browser, but the center spread of the book was a half-downloaded page, so you kind of understood the user experience, the context of that work.

I also wanted to say something about e-flux: even when I'm reading one of the publications—I mostly read the PDFs or one of the books—it always feels really networked to other activities that e-flux is involved in: exhibitions, Supercommunity, the commenting forum. It's a way to approach publishing that can feel very personal, even if it's very theoretical, because it's tied into this exciting network.

Kaye: I feel like we're in a very different position than certainly MoMA or The Met: we don't have a museum. It's just e-flux doing e-flux. It's a great position to be in as an editor because there's a lot of freedom. But it is more about creating those linkages and those spaces between. The forum that Zachary is mentioning **and the** is called e-flux conversations, and it's sort of taken on a life of its own. People can talk about what's being published instead of just looking at it. You can have a more personal experience or discussions with other readers, etc., and I think that there is not that moment of presenting the publication to the people in charge because they're the same people. *[Laughter]*

That is the case with the exception, I will say, of our publishing partners. So Verso is going to have their specificities, University of Minnesota Press, MIT Press, too. Luckily we've been fortunate to have great partners and there's a lot of trust in terms of our editorial voice and how much trust we put in our authors. It's more like they have different expertise in print publishing that we just don't have.

Hannah: I will say the one thing about being the more established publications department within a museum is that we are also meant to be a revenue-generating department. We do have to run it as a business, which is a lot of pressure. It can't be all about the educational outreach. It can't be all about the mission. At the end of the day, we have to make sure that our books make money. So that's a big concern for us and a lot of what drives our publishing program as well.

Jake: We covered the way in which the spaces you guys are working in—whether it's the internet or this discursive theoretical space, or the physical space of the museum—are brought into these books. After publication, how do these

books then relate back to the spaces that they come from?

Mark: I guess I think of it as being more outward-facing in a way. Not coming back to the spaces but projecting it outward. I guess I'm completely in the same place that Hannah is at MoMA. We have a triple mission. One is to spread The Met's scholarship and knowledge of its collections as widely as possible. Second is, indeed, to bring in revenue for the program, for acquisitions, for various sorts of things. And the third is to act as a kind of ambassador for the museum by the nature of the books, the presentation of the books, the quality of the books, and various other forms of publishing we do. We are representing the museum and are sort of standing in for it. People will react to it based partly on what they see and what we're producing and that's going to reflect on their vision of what The Met is.

I'm always very aware of the fact that really what we want to do is project outward and make The Met seem less parochial, because I think there is a little bit of that based into the traditional established museum experience. There is a kind of a center-of-the-universe aspect to working in a cultural institution and that's something that I'm always trying to break down because I find it a bit stifling.

Kaye: I think ideally for us, too, there is an outward-facingness and the books and the journals can be sort of animating agents or vessels, but I also think some of the nicer things that have happened, say,

when we published a specific book, is that we're then able to organize a large conference around it, and that is a whole other level of ideas coming together and spreading out, and a whole other audience. We've done events in all different kinds of places, and so there's that literal, physical bringing of the ideas into a different space: it's out of our hands and becomes a launch pad for other forms of discourse.

Web

e-flux journal, now in its tenth year of existence, is a contemporary art publication that, I think, sits in the space between animating or resurrecting very specific pasts and holding court for current and urgent discourse that emerges on and around contemporary art that likewise tend to get less air time than they deserve. In other words, I believe that the editors and many authors of *e-flux journal* aim to animate the pregnant space between timezones. Here I mean that as editors, I understand us to move in an outward spiraling, venn-diagrammatic pattern between working with writers, translators, and thought-archivists to unearth repressed strains from the historical avant-gardes of philosophy and aesthetics, and as editors holding taut the gaps left in current art discussion and contemporary written histories, in order that authors rush in to fill the holes and steer existing paradigms toward needed, productive new resonances. This often involves the fact of writers, many of for whom English is not their first, primary language, resurrecting from the past or present ways of looking, seeing, producing, hearing, and criticizing, that upend or provide the desperately needed other side of the story—there are plenty of other places to read often "Western," or often "Eurocentric," even "New York High Modern–centric," or art discourse stemming from and focused other centers of Empire. This is not to say that we don't fall into those same traps, nor is it to pretend that we sometimes miss the mark.

Over half of our issues per year focus on a theme—for example, the summer and this coming September 2018 issues (#92 and #93) are intended as a pole vaults or arks or arcs for writing on feminisms. Other times the editorial web is spread wider, but nonetheless with a variation on the abovementioned organizing principles in mind.

We publish nine issues of *e-flux journal* per year, and mostly live in the digital realm, although we have a network of distributors at 100-some institutions through-out the world, who are free to print, distribute, and if they wish to sell, copies of a PDF booklet version of the journal.

We also have four book series, giving physical paper and page space to specific artists, intellectuals, and strains of thought or inquiry. Our original book series is with Sternberg Press, which consists of a mixture between monographs by artists and philosophers and collections based on themes from *e-flux journal* such as labor, the Internet (and it not existing), and taking love as a serious subject of inquiry. *e-flux classics* with University of Minnesota Press focuses on bringing to light historical works that are little known or haven't before been translated into English, yet have had significant impact on avant-garde art movements or, for example, museology. (See *Avant-Garde Museology*, 2015.)

Along somewhat similar lines, together with MIT Press we've recently published a collection of translated historical texts on *Russian Cosmism*—the proponents of which believed in immortality and resurrection for all—and in some cases that this

was the only and ultimate way to achieve true communism. A review of the book published recently in the Los Angeles Review of Books describes the philosophy very well:

> Cosmism, then, is the practical leveraging of fantasy and science fiction as a radical force for human struggle and liberation. It seeks not just the preservation of life as we know it, but the fundamental transformation of it. Scientists and writers like Tsiolkovsky, Bogdanov, and Svyatogor use the sheer power and materiality of fantasy and science fiction as a wedge to push humanity beyond the very brink of its capacities, risking—no, inviting—a collective change in humanity beyond all recognition.[1]

Those are, ideally, just the kinds of discourses and movements for which *e-flux journal* creates space.

Also in the last year we published *Supercommunity: Diabolical Togetherness Beyond Contemporary Art*, with Verso Books. This was both a printed collection and continuation of the Supercommunity Project initiated at the 56th Venice Biennale. Since this chapter is about publishing in Spaces, I also want to focus on that as an interesting example of publishing in a literal, specific Space—in addition to posting each of the eighty-eight texts that comprised the Supercommunity issue on a specially designed website each day, excerpts for each text were designed and physically pasted daily onto a billboard in the Giardini for the duration of the exhibition.

There's a quote from the music world that's stuck with me, and that we cited in the editorial for the summer feminisms issue.[2] It's from the late American composer Pauline Oliveros. Oliveros defines "raw listening"—one of the practices at the foundation of her decades-long musical and educational practice. I continue to wonder to what extent it can relate to publishing—or editing—or specifically for our purposes here, how it might relate to our roles of publishing in/with/around various art spaces:

> Raw listening, however, has no past and no future. It is the roots of the moment. It has the potential of instantaneously changing the listener forever.

> Here is one of my practices: Listen to everything until it all belongs together and you are part of it.[3] 📖

Until it all belongs together

[1] Aaron Winslow, "Russian Cosmism Versus Interstellar Bosses: Reclaiming Full-Throttle Luxury Space Communism," *Los Angeles Review of Books*, August 18, 2018: https://lareviewofbooks.org/article/russian-cosmism-versus-interstellar-bosses-reclaiming-full-throttle-luxury-space-communism/.
[2] Julieta Aranda and Kaye Cain-Nielsen, eds., *e-flux journal* #92—"on feminisms" (Summer 2018): https://www.e-flux.com/journal/92/206017/editorial/.
[3] Pauline Oliveros, *Sounding the Margins: Collected Writings 1992–2009* (Kingston, New York: Deep Listening Publications, 2010), 7.

So you want to

Since 1996 **Rhizome** has championed born-digital art and culture, with a focus on the diversity of practices known as net art. Recently, with a surge of exhibitions, scholarship, and events including such work, we've noticed many publications featuring screenshots of browser-based artworks. There are numerous problems that arise when translating such works to print, so we've compiled a few simple guidelines to help guide others through that process.

print a screenshot

↘ Include the browser in the screenshot: websites are not fixed or self-contained, but are always being actively rendered by a browser. The frame of the browser adds vital context to your screenshot.

↘ Make sure the full URL is visible in your screenshot. URLs signify ownership and control, and they are sometimes used creatively by artists.

↘ Screenshot as PNG: a PNG image preserves the color and position of every pixel as-is, while JPEGs introduce artifacts and distortions.

↘ Make sure the image is visually bound. Without a boundary, a website with a white background will just blend into the paper on which it is printed. Boundaries, such as scrollbars, can also indicate important interaction cues and hint at parts of the work not pictured in the screenshot.

↘ Don't mess with the pixel resolution ("DPI" or "PPI")! Scaling up or down screenshots in apps like Photoshop can introduce interpolation, destroy important information, and produce unwanted visual artifacts (as opposed to the visual artifacts the artist intended, such as the lossy compression in fig. 1).

Note: these are generally applicable principles. Some works may require more specific treatment. For more info on this topic, seek out the long-form version of this piece published at rhizome.org.

of net art work

FIG. 1 This lossless PNG image reproduces all pixels as crispy squares, faithfully showing the contrast in between the clean default user interface elements rendered by the operating system and the artist's use of a low-quality JPEG background. The screenshot is just 794×574 pixels and that's ok.

FIG. 2 This screenshot has been saved as a JPEG and scaled up using "cubic" interpolation. Compression artifacts and blurriness massively distort the impression of the artwork. While the pixel size of the screenshot has increased to 2382×1722, the image looks much worse. Don't do this.

Nonprofit Art

Joanna Ahlberg
 Managing Editor
 at The Drawing Center
Noah Chasin
 Executive Editor
 at The Drawing Center
Camille C. Drummond
 Publisher at Pioneer Works Press
Miriam Katzeff
 Co-founder of Primary Information
Lesley A. Martin
 Creative Director and Publisher,
 The PhotoBook Review
 at Aperture Foundation
Craig Mathis
 Bookstore and Distribution
 Manager of Printed Matter

Sharon Helgason Gallagher
 moderator, President & Publisher
 of ARTBOOK | D.A.P.

Sharon: What I wanted to ask each of you is what you can do as a nonprofit on the publishing side—what does that enable you to do that a commercial house would not be able to accomplish?

Miriam: From the beginning we knew that we wanted to make books that were affordable for people but we also didn't want to shy away from producing the book in the way that the artist wanted. So we're not going to make a book black and white because it would be cheaper if the project really needs to be in color. We also pay artists, and a lot of for-profit publishers consider just doing a book with an artist to be promotion enough. Or perhaps they'll tell the artist, either you're going to pay to produce it or you need to find the people to put up the money.

For us it was really important to make books that were widely distributed. With our books, we start at editions of 1,000 or more. Knowing that we wanted to focus on these things and that we would have to work with a distributor, we essentially lose money on each copy that we distribute, but we want to have the best distribution for our books, so we offset that with grants and fundraising.

Sharon: What about Aperture on the other side? I know you also co-publish with publishers, particularly from Europe, who are commercial houses. You don't just limit yourself to trading with other non-profits.

Lesley: I think that's one strategy to facilitate taking on the risk and the investment in the development that is required for making a beautiful lush book that has tiny margins, which would never fly at a house that was really looking at the bottom line. That said, we also need to have a model that's sustainable, so we do offset that risk with fundraising, creating special editions, and cultivating that obsessive reader and viewer who is willing to pay $80, $100, $150, for something that's really beautifully crafted. I would say maybe akin to The Drawing Center, just to have a single line of publishing focusing on photography is pretty much a commercial folly right there.

Sharon: I think that leads naturally to The Drawing Center: how do you straddle the mission to produce an exhibition

Publishing:

catalog in conjunction with the show and to make a book that stands on its own two feet completely apart from that, and how does being a nonprofit let you accomplish that?

Noah: Going back to your original question of how being a nonprofit shapes the publishing, we're obviously constrained in a certain way, but we're constrained to a certain format that becomes a kind of indexical relationship to the exhibitions. You have an exhibition and you have a catalog. It is a one-to-one relationship. So the series of *Drawing Papers* is in fact also a chronicle or a catalog of all the exhibitions that the institution has had. And starting with the first one that was bound, we now have a very specific format: a consistent and limited page run, a certain number of images. While it's not quite a journal, it's also not quite a catalog or a book either, at least the way I think about it, and I find that to be a really compelling model that you don't see that often.

Joanna: I think that because it's so important for these books to both accompany the exhibition when they are open, because that's when we sell them, and also to exist after the exhibition is closed, because it allows the project to have a life beyond New York and beyond the run of the show, we had to figure out a way the editorial side and the design side and the print production side, with two or three part-time staff people, can produce a sort of alarming number of books very quickly. So the books are designed in such a way that

we're certainly not reinventing the wheel every single time.

The thing that I particularly love about the series is that if you spread a number of the books out, you're going to have a twenty-four-year-old emerging Chinese film artist next to the Gerhard Richter book and there's a kind of amazing democracy to the series in that way. And just the pleasure of doing these books for an institution that has a development team that does fundraising means that in our editorial meetings we don't have to think about, "Is this a big name artist? Is this a big name author? How big is their name going to be on the cover?" We don't have to workshop cover images the way that a commercial publisher would. There are not too many cooks in the kitchen either.

Camille: We're in a very unique position because of the particular mission of Pioneer Works, which is to make culture and art accessible to all as much as possible. We try by having free programs and such, but also deeply embedded in our mission is providing an environment for experimentation and new ways of looking at pretty much any of our disciplines, and supporting the artists who come through as much as possible as well. So with the press, I feel like it ends up being an extension of everything that's touching Pioneer Works in some way.

We only do a maximum of six books a year right now and being able to nurture each title is really important to us. Being able to rely on our development team to help bring those projects around is really something that we benefit from, and because our bookstore's mission

Diverse

is that reading is at the foundation of all creative practice, that really drives who we choose to work with.

Our new narrative program also is supposed to be a space where we are fostering publishers, authors, artists that want to solve problems by asking questions like, how can we publish something that can't be published somewhere else? We have a couple of books we're looking at that are basically rejects from academic presses. And Pioneer Works' mission is kind of to solve some problems that exist in the university; it's a very pedagogical learning space and in that it's a social practice. We're trying to make an environment where books can be published that might not be able to see the light of day with a commercial publisher, and that feels really good.

Sharon: Craig, I only recently learned that Printed Matter was started as a company when Lucy Lippard became involved. The idea was that people were going to be able to make these artists' books and they were going to be able to sell on a commercial basis and be able to pay the rent and pay the staff and that didn't last very long, then it became a nonprofit. So I would like to ask you— from your unique standpoint both on the publishing, but for people who are nonprofit publishers, your actual role in selling them is probably much more tasty to people *[laughter]*—how does being a nonprofit work for you on a day to day level in your decision making?

Craig: I think the idea of making artists' books accessible to everybody on a grand scale that would help you perpetuate your mission financially is a utopic vision and maybe a non-realistic one. But we've sort of traded that vision for a different utopia where we make books that aren't necessarily overt in their meaning. But when people come through the door we have the opportunity for, not just for our publications, but many of those that are there on the table are ones that I've sold to people from all over the world and I feel I'm in a very treasured place to have the opportunity to speak to so many different people about so many different types of books.

Their eyes might start to water when I'm talking about a book like ours which is called *Printer Prosthetic: Futura*, which is about an apparatus that was created to attach to an Epson printer, and you would then enter poetry from pamphlets that were produced in the '60s, and the artists would create different settings for that apparatus on the printer to create visual text on the page, to just make structures or sculptures on the page. So sometimes when I talk about that book to someone who's just looking for a design book or a typography book or a gift for their boyfriend or something, it's an opportunity to open people's eyes to really extraordinary projects. As a not-for-profit, as I've been informed many times, the intention is to promote the book work, the art book, the artists' book based purely on its content not on its sales projections.

Sharon: If the for-profit motive isn't what is driving you, how do you motivate the stage after the making of a book, the

stage that's about doing why we made the book in the first place, which is getting it out into people's hands?

Lesley: I'll jump in to say that even though we are a not-for-profit and we really value that and try to make decisions first from a mission perspective, we also do use the trade publishing system. Chris Boot, who is the Director of Aperture, likes to say we create smart interventions in the commercial market. So we're not necessarily workshopping the covers of things with a marketing team, but we do want to see the books on the shelves. We want them to be seen all over the world and that is our mission. So there are different types of books, of course, and we set our expectations of print run and price point accordingly. Like, does this have a small audience, small being 500? Is it 3,000? Is it 5,000? The range of types of books within photography that we publish is pretty broad, so we are assessing that external factor of the market but we're trying not to be driven and to have our decision-making first and foremost guided by that.

Camille: To piggyback off of that, we want to get the book into the world and we definitely want to make a little bit of money off of the book, break even on it at least. But I think that proving that we can do it smartly becomes very important to getting future projects funded by our board or by people who are so generous to support the press.

Sharon: Miriam, in your introduction, one of the things you named is, "I want to make these books affordable." That was right front-and-center—so if I write you

Models

a check, is that where a lot of my money goes? To take a book that would otherwise be $50 and is now $25?

Miriam: Yeah, I meant to answer your question earlier: we're concerned with sales, but we just have a formula where we don't anticipate making a profit off of any particular book. We don't want to have boxes of each title sitting in our storage for years. A lot of our titles sell out, but at the end of the day we haven't made $10,000 off a particularly popular title. I just think the audience for contemporary art is pretty small at the end of the day. But somebody could walk into Printed Matter, Spoonbill, The Strand, anywhere, and be drawn to a book and if the book is $60 they're like, "I don't know if I'm that interested." But if a book is $20 by a young artist they've never heard of, they're like, "Why not?"

When we publish an artists' book we want to keep our presence sort of discreet. There's not a ton of branding on our books. You can find information in our colophon about our funders and the book details but it's not like a coffee table publisher where there's going to be a giant logo on the front. So maybe that's just about trying to let the books speak for themselves, and then learning over time. A lot of our customers are repeat customers, so they're coming to our website, seeing a lot of this information, learning about us as publishers.

Craig: I feel like sometimes when publishers put books together, that they of course are thinking about who

the book is for, but once it is out there, where is it in the store? Where is it going to fit? That was also part of the first talk in the *Recto / Verso* series. Some of the things that Printed Matter gets are pretty outlandish. They're oversized or very undersized or very delicate. You have to bear that in mind and many people of course enjoy that sort of nature of the physical object. But in terms of that publisher, how does that fit in with all things that they've been doing up until that point? Then in the greater sense, how is that community they perceive going to respond to that?

Sharon: For The Drawing Center, you mentioned a thing that is a big motivation for most, or all museums and galleries, which is that the exhibition is now closed, this book is now its life. If someone has come—they're interested in drawing, they came to this show, they bought the book—how can you get them to become part of your community?

Joanna: We know and we rely on not just The Drawing Center's audience, but the *Drawing Paper*'s audience, and we know that there are people who just buy them, they don't necessarily need to know what that particular project is about or who wrote the essays, they're just going to buy them, and we're grateful to those people and we've considered some sort of subscription-based program, I think our development team has even looked into different membership levels that maximize the books as a community-building tool.

Camille: *Publishing as Artistic Practice* came out through Sternberg Press a few years ago and talks a lot about the transi-

tion from the book to publishing and the book as art object; but we're growing in a direction where it's now publishing as practice. I feel like with that energy it's a very specific moment and it's made me think a lot about how, on the trade side, there are a lot of resources like trade fairs, associations, organizations that exist to connect you as a publisher with bookstores and connect you with other organizations to give those books that extra life and to get out of just the front list and really have advocates for the backlist.

Do we need a distributor to maybe take on more of a role of an association? I know D.A.P. has plenty of resources for helping you reach out to other museums, institutions, libraries, bookstores and reps—you know, I love our D.A.P. rep, but I feel like there might be something a little more association-like that could be needed—something similar to the American Booksellers Association. Maybe not that far, but that could provide for this very particular moment that's happening in publishing with a lot of artists' book publishing and micro small press publishing becoming more professionalized.

Craig: In terms of promoting or trying to create community or support, I think of the New York Art Book Fair and LA Art Book Fair and our bookstore, I think of everybody in the audience, everybody on this panel and everyone who comes into the store as ambassadors for this type of culture.

I had attended the art book fair for many years just as a guest or fan, and I would tell people who came to New York,

it's the best thing that happens in New York every year. It's massive and there are tons of people and tons of publishers from all over the world with incredible books and art. And the thing that I experience at the store every day is a condensation of that feeling. I sit right by the front door and see people come into the store and it's a rare day that I don't see at least ten different sets of people's eyes pop out of their head when they walk in. They're looking for different types of books and all of the people, even the people who are just like, "What is this place and can I use the bathroom?" *[laughter]* are opportunities to try and sort of proselytize the message of this type of work.

Whether it's through social media or book fairs or talks or publications, the way that I see it is that every chance is an opportunity to talk about a particular artists' work. My goal is to sell books. That's what I want to do. I'm in service to the people who create things. I'm not an artist or bookmaker. I'm someone who loves artists' books and the craft behind it and this sort of feeling and ownership. That's how I perceive the community and my place in it, and how I feel an organization like Printed Matter best serves the public: by being an example of something that's constantly trying to put those things out at the forefront and trying to talk about them even if peoples' eyes are sort of glazing over when you're talking about some weird book. We hope that we can convey that passion to everybody.

Sharon: Looping back around, the photo book community is its own special species. We certainly know when we go to a photo book fair or a photo fair versus an artists' book fair, it's a very different community.

Lesley: Absolutely, there is a fiendish geekery out there that I love and consider myself to be part of, and it really did come from bookmakers and photographers themselves, Martin Paar being sort of the key example as somebody who became a missionary for the cause of the photo book. There is a particular relationship of photography to the printed page. Certainly in the old school days you needed to print your photo in order to experience it, so putting it in a book was just a different form of manifesting the work. It's different from the book that tries to capture a sculpture and the experience of the sculpture. Photographs are serial. They're about linking and creating meaning through sequences of image, which makes them very suitable for the book form.

Sharon: So is there room for a bigger association of these visual books that embraces the photo book, that embraces the artists' book, that embraces interestingly-done exhibition catalogs—though maybe not all; there's a tricky line there—that this whole community could be helped by, whether it's a formal association, whether it's a Martin Paar figure, a champion that goes out there and make it bigger out in the rest of the world? Not here in New York and not just in in LA, but in Boston, Chicago, Houston? These are places where I think there are people who want to see these books but there's no place for them to go and see them, for the most part.

Craig: I do think that the sort of proliferation of book fairs and festivals around the world for artists' books certainly are opportunities for those communities to come together for all types of books. So I would say in lieu of a physical store, that's the store. Those artists who are standing behind the table with their artwork, they're the store. They're the ones communicating those messages. All of these different presses are probably fiercely independent, so the greater association idea, who would be the champion of that? Or if it's a collective? For Max Schumann, my boss, I don't know how the idea of being part of this big thing would fly, but I would be curious to know if anybody had any ideas, because I do think, on the indie side, it does benefit mom-and-pop small bookstores considerably.

Camille: There was something that we tried this year with the Press Play fair we host at Pioneer Works, which kind of grew out of something that Sonel Breslav, Director of Fairs & Editions at Printed Matter, did, a conversation that happened at Bushwick Art Book & Zine Fair, BABZ. There was a panel conversation that happened there on artist-run reading spaces, and after they used the platform Arena to collect resources. Arena is like Pinterest for creatives. If anyone hasn't been on it, it's highly addictive for bookmarking and collecting and such. But it grew into a really great resource share. For Press Play, we invited all of our exhibitors this year to contribute a bunch of resources—PDFs, pamphlets, book recommendations, all these things that could make the fair live on outside of its duration—and we've published those to Arena and

Sustainable

now its a significantly growing community where people can check in and we can keep talking about it and advertising it, and I feel like for us we're really hoping to jumpstart that kind of networking in a more formal sense.

I'm independently working with someone from Recess and a gallerist in Crown Heights, Brooklyn, to try to figure out how to solve the problem of distribution from African diasporic territories in terms of getting the books published here, there, and getting the books published there, here, without the proper channels. We jumped on a video chat with Alexis Zavialoff from Motto Berlin and the three of us were sitting in this video call and thinking, "Wow, what if there were more formal channels for us to have these conversations?" I think we all sort of generally reach out to each other, as any booksellers or bookstores or publisher do to swap thoughts, but it would be interesting to have a collective or network or something that helps us not just get advice from each other but then share those resources in a more public way.

Noah: When Craig was talking about retail spaces in particular, I was thinking about The Drawing Center's store as the absolute antithesis of Printed Matter. At The Drawing Center you basically have the exhibition catalogues for the current shows and a few others, whereas Printed Matter, I've certainly over many years had that googly-eyed experience of walking in. But I love both of those experiences because on one hand, it's

Practices

very simple. There's the show and the catalogue and I want to have that as a remembrance of the show. But I know when I go into Printed Matter I have that almost archival experience of being able to go through not only historical but also different media. I believe people who love books as a physical object also like places as a real three dimensional space.

So my wildly utopian idea for you would be, there just need to be more spaces that can sustain that sort of physical interaction with the object. Because I just feel that when I am looking for something online I get lost in the endlessness of the possibilities as opposed to the discrete number of books that are in a shop or an exhibition gallery or something like that. 📚

Here's an amusing game: when in a library, ask someone under the age of thirty if they know where the "stacks" are located. More often than not, the answer will be a quizzical look and a stammered inference. Shelves of books have become so much extraneous mise-en-scène—the collective archive of information can be acquired elsewhere and much more easily. An endless supply of downloadable PDFs, EPUBs, issuus, and online subscriptions have evacuated the atlas of situated knowledge and removed the boundaries of its formerly measurable magnitude. The experience of browsing a virtual database cannot equate to the phenomenological experience of moving from Point A to Point B in search of shifting subject matters. Demate-rialized files are fragmented and fleeting. The surprise and delight of propinquity eludes the surfer/flâneur. There is no related text propped up on one side or the other that might strike a note of curiosity because, to be precise, *there are no sides*.

The printed book is the materialization of solitude and the externalization of imaginary narratives. Bibliophiles love books in equal measure to their adoration of spaces in which bound volumes are to be found. Walter Benjamin, one of the twentieth century's greatest book lovers, put it this way: "The purchasing done by a book collector has very little in common with that done in a bookshop by a student getting a textbook, a man of the world buying a present for his lady, or a business-man intending to while away his next train journey."[1] For the book-hound, the book-store and its treasures portend an unknown eroticism, or what Roland Barthes calls "the inter-text": "the impossibility of living outside the infinite text … the book creates meaning, the meaning creates life."[2]

The great, and gravely underappreciated, Hungarian-French architect Yona Friedman had his first-ever exhibition in the United States at **The Drawing Center** in Spring 2007. Fearful, or perhaps just uninterested in traveling to New York, Friedman faxed images for the show that were then affixed by The Drawing Center staff to a grid of structural cardboard tubes bound together by unspooled rolls of Kraft paper in order to create a matrix of surfaces in the gallery space. The drawings originated in France, became dematerialized via transatlantic fax transmission, only to be reified in print form for the purposes of presentation. As Friedman wrote below a series of two drawings (shown here): "A void gets its signification through its boundaries (the 'envelope'). A void gets a meaning as well through the things inside."

A bookstore or a gallery might serve as the boundaries or envelope of a space otherwise undifferentiated from the vastness around it. Likewise, a book's cover and its binding serve as its envelope. Images and words and graphemes and traces supply the unyielding "things inside." An empty, three-dimensional space is mean-ingless when trimmed of program, of internal scrutiny—be it people, words, or a deliberate emptiness or void. The bibliophile thrives when the void forsakes its spatial parsimony in order to accept nourishment. ◆

[1] Walter Benjamin, *Illuminations*, (New York: Schocken Books, 1969), 62–3.
[2] Roland Barthes, *The Pleasure of the Text*, (New York: Hill & Wang, 1975), 36.

3

A void gets its signification
through its boundaries (the "envelope")

4.

A void gets a meaning
as well through the things inside

68

YONA FRIEDMAN
ABOUT CITIES

THE DRAWING CENTER
FEBRUARY 24, 2006–APRIL 7, 2007

Edward Hallam Tuck Publication Program

Printed

Founded in 1976, **Printed Matter, Inc.** is the world's leading non-profit organization dedicated to the dissemination, understanding, and appreciation of artists' books and related publications.

First established in Tribeca by a group of individuals working in the arts (among them artist Sol LeWitt and critic Lucy Lippard), Printed Matter was developed in response to the growing interest in publications made by artists. Starting in the early '60s, many of the pioneering conceptual artists (as well as performance, process, environment, sound, and other experimental media artists) began to explore the possibilities of the book form as an artistic medium. Large-edition and economically produced publications allowed experimentation with artworks that were affordable and could circulate outside of the mainstream gallery system. Printed Matter provided a space that championed artists' books as complex and meaningful artworks, helping bring broader visibility to a medium that was not widely embraced at the time.

[2]

Matter

After thirteen years on Lispenard Street in Tribeca, Printed Matter moved to a location on Wooster Street in Soho in 1989. The spacious bookshop with large storefront windows allowed for the development of expanded public programming, including more exhibitions and events, and contributed to the cultural vibrancy of the neighborhood. In 2001 Printed Matter made its move to Chelsea, which had since become New York's contemporary arts district. In 2015 the store relocated to its current space on 11th Avenue. The new location features a much larger bookstore spread across a ground floor and a large public stairwell leading to a mezzanine level. The space features a dedicated exhibition area, as well as increased office space for its growing staff. Printed Matter's new home provides a much more comfortable environment for visitors to engage with the ever-growing inventory, and for a busy schedule of public programs.

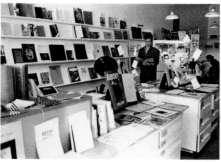

[1]

FIG. 1 & 2: 7 LISPENARD STREET, NEW YORK, NY (1977–89) | FIG. 3 & 4: 77 WOOSTER STREET, NEW YORK, NY (1989–2001)

[3]

[4]

Mission & History

Artists' books continue to provide a remarkable reflection of contemporary artistic practices—tracing and even leading many of the most important developments in the historical trajectory. In the face of the ongoing proliferation of digital media and information, there has been an astounding resurgence over the past several years in both artists' publishing and public interest. In tandem with this truly international phenomenon, Printed Matter founded the New York and Los Angeles Art Book Fairs (in 2004 and 2013 respectively), which have become the world's largest venues for the distribution, investigation and celebration of artists' books and art publishing. It is thrilling that Printed Matter's mission continues to be resilient, and remains more relevant than ever. ◈

[5]

[6]

[7]

JOANNA AHLBERG is the Managing Editor of the publications program at THE DRAWING CENTER and a Principal at AHL&CO, a New York-based creative consultancy and design studio. She is also the author of *Diary of Your Home: Ideas, Tips, and Prompts for Recording and Organizing Everything* (Rizzoli, 2018).

JAKE BRODSKY is an Editorial Assistant at HAUSER & WIRTH PUBLISHERS. Since its founding in 1992, Hauser & Wirth Publishers has been devoted to the presentation of unique, object-like books and a rich exchange of ideas between artists and scholars.

KAYE CAIN-NIELSEN is Editor-in-Chief of E-FLUX JOURNAL. Previously she served as a managing editor of *e-flux journal*, while expanding e-flux's ongoing and recently established books series (with Sternberg Press, University of Minnesota Press, Verso Books, and the MIT Press). After studying at Bard College, Kaye was managing editor and special issues editor for *Guernica—A Global Magazine of Art & Politics*, among other publications. She remains a writer and musician living in Queens, New York.

NOAH CHASIN is Executive Editor at THE DRAWING CENTER. Trained as an architectural historian, he teaches the history and theory of urban design at Columbia University's GSAPP and is affiliated faculty at Columbia's Institute for the Study of Human Rights.

CAMILLE C. DRUMMOND is a cultural producer and the Director of Publishing at Brooklyn-based art center PIONEER WORKS. In addition to serving as buyer for Pioneer Books and publisher of Pioneer Works Press, she develops programs that champion reading as the foundation of all creative practice, and advocate that publishing is essential to accessing the arts. Prior to this, she was the Event and PR Director for WORD Bookstores and a News Associate at Reuters. A native of Los Angeles, California, she now lives in Brooklyn, New York.

ZACHARY KAPLAN is Executive Director of RHIZOME, an organization championing born-digital art and culture through commissions, exhibition, and preservation programs. Founded online in 1996, Rhizome is affiliated with the NEW MUSEUM—the two organizations pursue joint art and technology programming. Prior to working at Rhizome, Kaplan worked at the Renaissance Society, Chicago, and MOCA, Los Angeles.

MIRIAM KATZEFF is the Director and Co-founder of PRIMARY INFORMATION, an independent curator, and a former Director at Team Gallery (2005–14). At Team Gallery, she worked closely with artists to help produce artworks and curate exhibitions including *Parasitic Gaps, Forced Exposure, Re: Empire, 5XU and Hung,* and *Drawn and Quartered.* As an independent curator, she has organized a program of political video work at The Swiss Institute and co-curated exhibitions at the Institute of Contemporary Art Philadelphia, MoMA PS1, and White Columns with Primary Information Co-founder James Hoff.

HANNAH KIM is the Business and Marketing Director in the Department of Publications at THE MUSEUM OF MODERN ART, New York. MoMA's publications program has been an integral part of the Museum's mission since its founding in 1929. MoMA publications exemplify the scholarship of the Museum's staff and associates, and serve as a valuable resource to scholars, students, and art lovers alike.

LESLEY A. MARTIN is Creative Director of the APERTURE FOUNDATION and publisher of *The PhotoBook Review*. Martin's writing on photography has been published in *Aperture, FOAM,* and *IMA,* among other publications, and she has edited over one hundred books of photography, including *LaToya Ruby Frazier: A Notion of Family,* and *Rinko Kawauchi: Illuminance.* In 2011, she co-founded the Paris Photo–Aperture Foundation PhotoBook Awards. Martin has curated exhibitions that have traveled both nationally and internationally, including *Mickalene Thomas: Muse, The Ubiquitous Image,* and *Aperture Remix,* a commission-based exhibition celebrating Aperture's sixtieth anniversary. She is currently a visiting critic at the Yale University School of Art.

APERTURE FOUNDATION was founded in 1952 as a "common ground for the advancement of photography" to provide a forum for the photo community to connect with the most inspiring work, the sharpest ideas, and each other—in print, in person, and online. To fulfill its mission, Aperture produces a series of publications, public programs, and exhibitions each year.

CRAIG MATHIS is the Bookstore and Distribution Manager for PRINTED MATTER, INC. Founded in 1976, Printed Matter, Inc. is the world's leading nonprofit organization dedicated to the dissemination, understanding, and appreciation of artists' books and related publications. The shop currently stocks over 15,000 titles ranging from contemporary artists' books, zines, and multiples to many rare and out-of-print titles and ephemera. Prior to joining Printed Matter in the spring of 2017, he served as the Operations Manager at powerHouse Arena, a 10,000 sq. ft. bookstore, events space, and gallery, located in DUMBO, Brooklyn from 2008–17.

MARK POLIZZOTTI directs the publications program at THE METROPOLITAN MUSEUM OF ART in New York, and has held executive and editorial positions at Random House, the Museum of Fine Arts, Boston, Grove Weidenfeld, and David R. Godine. He is the author of eleven books, including *Revolution of the Mind: The Life of André Breton,* which was a finalist for the PEN/Martha Albrand Award for First Nonfiction, as well as of essays and reviews for the *New York Times, The New Republic, Wall Street Journal, The Nation, Bookforum,* and elsewhere. The translator of more than fifty books from French, he received an American Academy of Arts and Letters Award for Literature and is a Chevalier de l'Ordre des Arts et des Lettres.